CHRISTCHURCH

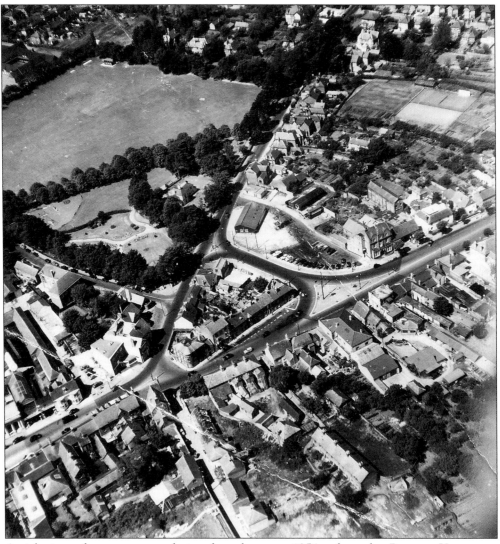

Aerial view of town centre, dating from between 1954, when the Brewery House was demolished (next to Bow House in the High Street) and the roundabout encircling the remains of the Pit Site was created, and 1957, when the Antelope Hotel, at the apex of the Pit Site, was pulled down. Barrack Road was yet to be widened to four lanes, the bypass had yet to slice through the lower end of Bargates, Pound Lane terminated in a farm and not a supermarket, and the car park, now called Bank Close, was still occupied by brewery buildings.

IMAGES OF ENGLAND

CHRISTCHURCH

SUE NEWMAN

TEMPUS

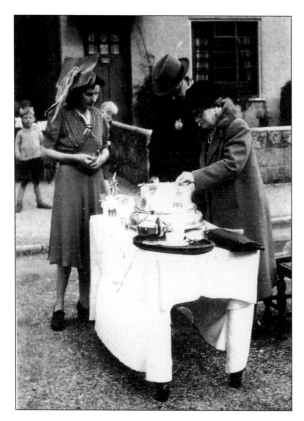

A VJ party in Portfield Close, September 1945, showing a young lady in clothing typical of the wartime era: draped moss crepe dress finishing at knee length for economy, teamed with a striking 'mortar board' hat, with the hair swept up away from her face and clumpy-heeled 'utility' shoes.

First published 1998, reprinted 2005, 2007

Tempus Publishing Limited
Cirencester Road, Chalford
Stroud, Gloucestershire, GL6 8PE
www.tempus-publishing.com

British Library Cataloguing in Publication Data.
A catalogue record for this book is available from the British Library.

ISBN 978 0 7524 1050 0

Typesetting and origination by Tempus Publishing Limited.
Printed in Great Britain.

Contents

Acknowledgements

This book has been compiled with the assistance of many enthusiastic and knowledgeable people, to whom I am indebted for the loan of photographs or for information. I am particularly indebted to Mr Terry Tuck, but others who have given me the benefit of their wisdom or permission to use photographs are: Miss Ruth Abbott; Mr Richard Aldridge; Mr Mike Allen; Mr Chris Austin; Revd Charles Booth; Mr Peter Cameron; Miss Alison Carter; Mr G.R. Clark; Mr Bob Croucher; Mr Ted Davey; Mr Fred Dixon; Mrs Silvia Druitt; Mrs E. Dunster; Mr John Elliott; Mrs Pat Furness; Mr Jess Gorick; Mrs Valerie Grieve; Mr and Mrs Grimsdale; Dr Brian Haywood; Mrs Pam Herron; Mr Michael Hodges; Mr Eric Lardner; Mr Kenneth Morgan; Mrs Mabel Norman; Mr and Mrs Bob Orrell; Mr Mike Parker; Mrs Mabel Perry; Revd Alan Sessford; Mr Jack Staddon; Mr Ian Stevenson; Mr Alan Vick; Mr Ray Weston and Revd William White.

Thanks are also due to Beaulieu Motor Museum, the Royal Humane Society and Sammy Miller's Motorcycle Museum.

Photograph credit for the following pages as follows (a = top, b = bottom):
Pages 4, 69b, 77, 84-5, 86a, 87-88 and 90 from the *Christchurch Times* appear by the kind permission of the *Christchurch Advertiser*.
Pages 72 and 73b appear by the kind permission of Christchurch Borough Council.
Pages 9, 10a, 17a, 19, 21-2, 24b, 26a, 28, 29a, 34a, 41, 42a, 43, 45b, 46, 47a, 48, 80b, 82b, 83b, 92, 94, 96, 97b, 98a, 100b, 103, 106b, 108, 109a, 112a, 119, 123 and 124b appear by kind permission of Classic Cards, Castle Street, Christchurch.
Pages 10b, 11b, 17b, 20b, 27a, 32a, 36b, 38a, 42b, 50b, 55b, 59a, 61a, 62b, 64b, 65a, 67a, 79b, 81a, 82a, 101b, 107a, 120b, 124a, 126, 127a and 128 are from the author's own collection.
Pages 38a and 55b appear by courtesy of the Francis Frith Collection, Shaftesbury, Dorset SP7 8AT.

Every effort has been made to trace copyright holders but the author apologises for any omissions.

A Note on Sources

Numerous works of reference have been consulted, both published and unpublished. The *Christchurch Times* is a principal source, also works by Herbert Druitt, Allen White, Lynne Rutter, John Barker, M.A. Edgington, Tom Kelly and Sheila Herringshaw and various documents and manuscripts in the Local History Room at Christchurch Library, the Red House Museum and the Dorset and Hampshire Record Offices.

Introduction

'The motor car is not popular. It makes too much noise, is a great deal too smelly and makes altogether too much fuss over the modest amount of work it seems able to accomplish. Perhaps it has a future in store but at present it has no very enthusiastic admiration... the motor car may be an abominable nuisance, but if so, it will probably be found to be one of those evils that have to be endured.' *Bournemouth Visitors' Directory*, 13 August 1897.

With these auspicious words, the long reign of the motor car began. This introduction will remark on its effects, as the changes apparent in the following pages can so often be laid at the door of this mechanical tyrant, over which for a century or so we have tried and failed to gain control. It will be seen that the price we have paid for the liberation it has given us is our enslavement to its precocious domination.

Within ten years of this prediction, a national Anti-Motor League had been formed, bewailing the misery inflicted upon the lives of the populace by a 'perpetual feeling of dread, terror, dust and stink' caused by motorised traffic, and the loss of life that was already being experienced as the conflict between these new road users and the existing ones began to be felt. Although fatalities did occur with horse-drawn traffic (the owner of the King's Arms hotel was actually killed after being thrown from his trap in 1920), the death toll from the new 'horseless carriages' far exceeded these in numbers. Furthermore, the objectives of the League extended to the protection of the livelihoods of those whose occupations were threatened by the change: 'farmers, corn-dealers, horse and carriage proprietors, livery men, saddlers, and nurserymen', a fear which in retrospect can be seen as amply justified, albeit Luddite in character. In the same year, 1906, a Royal Commission recommended the introduction of the new charge of 'reckless driving'. The danger now perceived from motorised traffic was so great that a national petition was raised in 1909 from an organisation called the Road Unions, specifically citing the level of noise the invention had brought to the previously quiet streets, ruining sleep, the pervasive dust raised on untarmacadamed roads, and the financial loss to farmers whose crops in those fields abutting roads became so dusty as to be unsaleable. Even before the advent of cars, the borough roads had had to be regularly watered to keep the dust down in summer.

The dust problem was, however, at last addressed in the borough a few years later by the application of tar to the roads, by which time, in a busy Easter, it was noted that 150 cars passed through the High Street in a single hour, a number considered to be immense. This was in 1912; the figures noted in 1920 suggest this had already doubled. A great quantity of charabancs also thundered through the town, filled with visitors sightseeing, or *en route* to other tourist spots east of Christchurch.

Further action to alleviate the situation was needed and an attempt was made just after the First World War to impose a 10 mph speed limit in the borough. It was defeated by the Ministry of Transport after a Town Hall enquiry, leaving the Town Council passing a resolution to find

a way of reducing the great damage to main road houses caused by the heavy traffic. In 1920, an observer was outraged by a car passing by the recreation ground at a speed of 40 mph. This seems a trifle now, so inured have we become to the frantic pace of traffic which is now commonplace but which our predecessors, recalling an era when the roads were shared in relative safety by draught animals, horse riders and pedestrians, found abhorrent and frightening.

Another consequence of the car's appearance was the conflict with other road users. Time and time again, reports of collisions between cars and horse-drawn vehicles appear, often resulting in the animal bolting and the trap or cart overturning, causing further injuries.

Notorious blackspots developed, notably that at Stony Lane at the junction with Purewell, and the number of collisions here, where the road was restricted and kinked, eventually led to the demolition on safety grounds of Magnolia House. This process had already been implemented at other awkward sites: the Antelope Inn and the Pit Site clearance; the removal of the Brewery House in the High Street; and ultimately the swathe cut through Bargates by the bypass of 1958. All these alterations had a drastic effect on the townscape, but it must be remembered that the tram in its day had necessitated the demolition and rebuilding of both sides of Bargates to widen it to accommodate the new tram lines.The advent of motorised traffic resulted, too, in the widening of many roads and encroachments on curtilages, examples of which appear in the text. The most radical was the widening of Barrack Road to four lanes in 1960, but the process could have been even more drastic: it was once proposed that the High Street should be rebuilt as a 60 ft carriageway with wholesale demolition proposed on the east side. Car parks, too, have been responsible for much demolition: for example, the brewery buildings in the Bank Close car park, and the house known as Little Dartmouth in the Wick Lane car park.

In parallel to this profound cause and effect, the rise in population must also be held responsible for enormous change. Comparisons in this respect in Christchurch are difficult to make, since the boundaries constantly expanded and contracted as portions were yielded to Bournemouth (Iford, Tuckton, Pokesdown), or acquired (Mudeford, Burton, Highcliffe). Figures from historical sources and the council show that the borough grew from 4,149 persons in 1811 to 5,693 in 1912 - approximately a century - then within another half century reached over 20,000 at the census and over double that number in 1992. The consequences for land use are only too apparent.

The photographs to follow bear witness to these observations and afford food for thought about the balance to be aimed for as we progress, and about what, in fact, progress actually means. Most of the photographs deserve a full page each to appreciate all the details; in lieu of this, readers will soon find that a good magnifying glass will reveal much more of interest in each picture than can be appreciated at first glance.

In compiling this collection, I am indebted to the generosity of the contributors, and the assistance afforded by those who provided information and advice. What follows does not claim to be comprehensive, depending as it does on the availability of material to illustrate the complexities of a history of a town after the invention of the camera. So many buildings, people and events are simply not on record, or have not come to light. Others have been extensively depicted before, and this offering is above all an attempt to reveal aspects of the history of the town and area not previously the subject of discussion or study. Emphasis has been placed on the ordinary, day-to-day aspects of life, as lived by the unremarked in the unremarkable, but not at the expense of leaving the well known literally out of the picture, and above all bearing in mind the observation of that unequalled local historian and scholar, Mr Herbert Druitt, that 'the object of history is to reconstruct the past for the benefit of the future'.

One
Around the Town

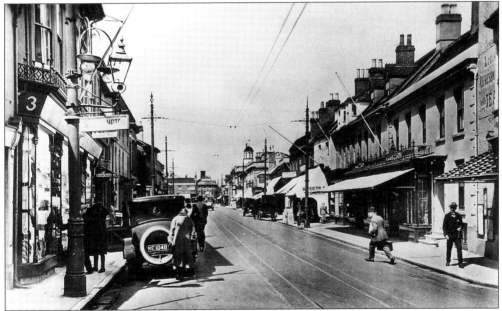

The High Street, c. 1930. This view is broadly similar today, the radical alterations brought about by demolition being mainly confined to the extreme ends of the street. The frontages though, have altered considerably, being far less ornamental in the 1990s.

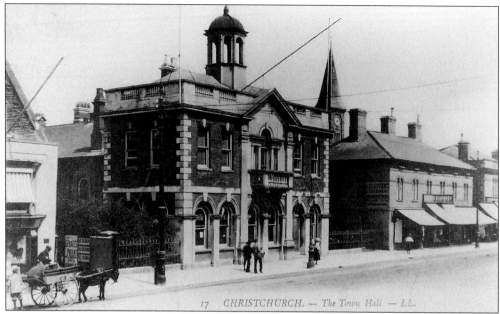

17 CHRISTCHURCH. — The Town Hall — L.L.

The Town Hall, soon after 1902 when the Art and Technical School was added at the rear as a memorial to Queen Victoria. We are fortunate to have retained this important High Street building, now Grade II listed. Proposals to demolish it were not only proposed in 1960, but actually passed. Through the intervention of twelve prominent local people who appealed to the government, a Building Preservation Order was obtained which saved the day - and the building.

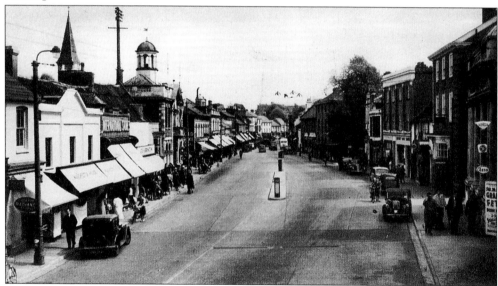

Looking down the High Street in the early 1950s. From this direction, the later losses are more obvious than on page 9; the whole of the left side up to the Town Hall has been redeveloped. On the other side, note the original 1914 curved window frontage of the post office, until recently an electricity showroom. The High Street was, until the bypass opened in 1958, the main thoroughfare to and from Southampton and London, so the refuge in the centre of the street was very necessary.

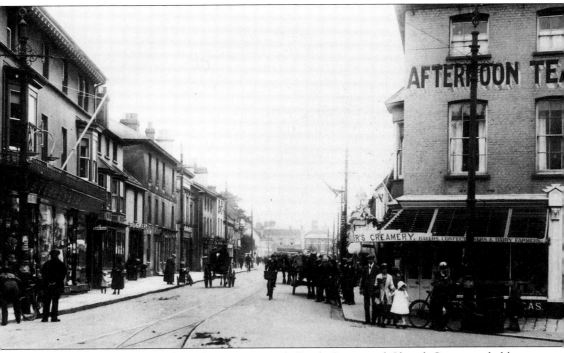

Looking up the High Street from the junction with Castle Street and Church Street, probably soon after the First World War. Formerly known as the Square, this junction was in earlier times the main trading area in the town, centring on the market house or Shambles which stood here from medieval times to 1855, by which time it had developed into the Town Hall. To the left is Ferrey's drapery, the oldest established business in the town, commenced in 1760 by Huguenot descendants. The trend towards chain stores forced its bankruptcy in 1936. Taylor's Creamery, opposite, moved next to Ferrey's after 1919.

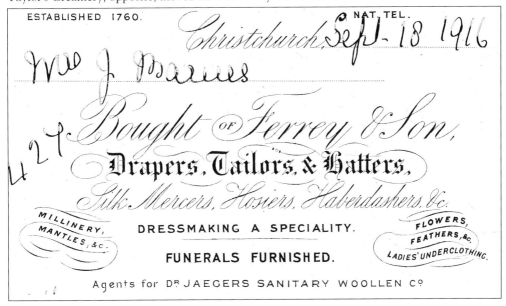

ESTABLISHED 1760. NAT. TEL.

Christchurch, Sept. 18 1916

Mrs J Barnes

Bought of Ferrey & Son,

Drapers, Tailors, & Hatters,

Silk Mercers, Hosiers, Haberdashers, &c.

MILLINERY, MANTLES, &c.

DRESSMAKING A SPECIALITY.

FLOWERS, FEATHERS, &c. LADIES' UNDERCLOTHING.

FUNERALS FURNISHED.

Agents for Dr JAEGERS SANITARY WOOLLEN Co.

11

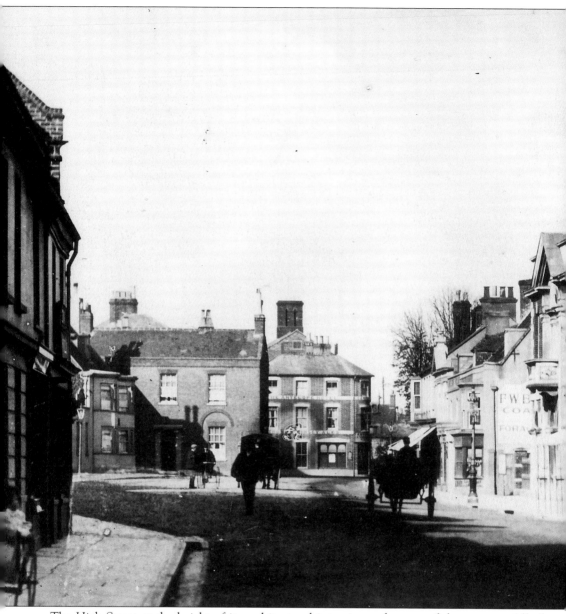

The High Street at the height of its architectural integrity at the turn of the century. All of these buildings evolved over the centuries long before the era of civic planning. The contrast of designs and materials and assortment of facades combine to create a harmonious scene, the cosy feel of which results from the increasingly protruding position of the buildings at the far end. Facing down the street, left, is the Brewery House, associated with the Christchurch Steam

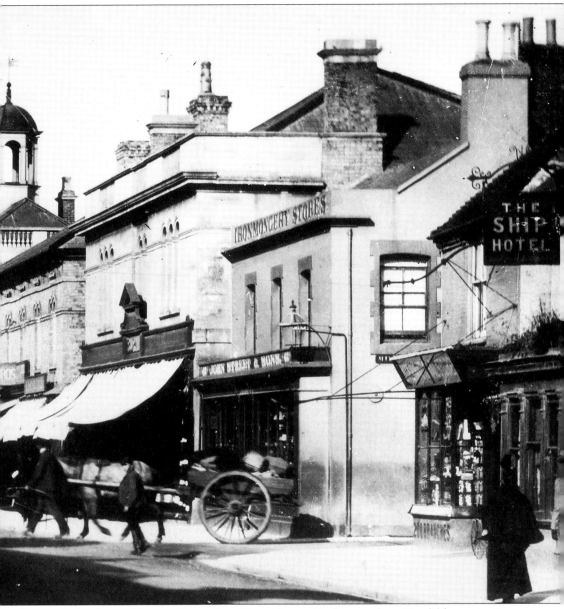

Brewery behind it, and its neighbour, Bow House; beyond is the Antelope Hotel (the projecting antelope emblem visible) which stood at the junction of the High Street, Barrack Road and Bargates. The shape of the street reflects its use for the great fairs of medieval origin until these were abolished in 1872. The pig market was held at the widest point.

A row of ten Victorian cottages which used to face the Quay; four more of an earlier date continued around the corner into Wick Lane. Until early this century, long gardens in front of the cottages led down to a wall dividing two of the three manors of Christchurch, and beyond this was the common land of Quomps. The wall was replaced by the road linking Whitehall with Wick Lane. Many of the occupants were employed in the fusee chain cottage industry of the last century. These humble 'two-up, two-down', homes, without either running water or inside toilets, were demolished in 1973.

Countryside in the town centre; just around the corner from these cottages, the view is towards the town in the mid-1930s. Beyond the left hand wall was Mr T.H. McArdle's Wick Lane Farm. His house can be seen projecting from the end of Silver Street on the right. Since this time Wick Lane has been straightened and consequently this house has gone. The farmhouse itself stood opposite, at the end of the Creedy path alongside Druitt Gardens. All the farmland, which at one time supported a dairy herd, was soon afterwards laid out as the Wickfield estate.

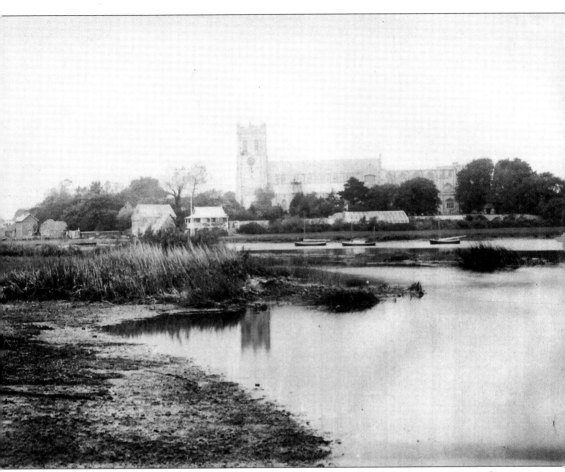

Taken in the early Edwardian era from Mill Mead, in the vicinity of the present Priory Quay marina development, or possibly from the Wick side of the Stour, this view shows the unimproved character of the Quay area at this time. On the right of Place Mill the first clubhouse for the Sailing Club is clearly shown; this was built in 1896. Place Mill was at the time still a working mill, having been purchased in 1890 along with the millstream and quay by the Town Council, together with the miller's cottage (left of picture). In front of the Priory, the greenhouse is at present the site of the pergola in the grounds against the ancient Priory wall.

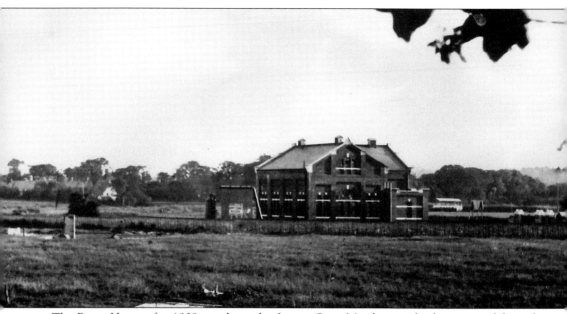

The Pump House of c. 1909 stands on the former Quay Meadows and is here viewed from the site of the present Princess Avenue; beyond the building is Quomps. Both areas were then virtual swamps, so were used as open rubbish tips to raise the levels. Quay Meadows originally belonged to the manor of Christchurch Twyneham, so was before the Dissolution the property of the Priory. Indeed, the pumping station was built on the site of the monastic fishpond. Quomps belonged to another manor: that of the Borough, and was conveyed to the town by Lord Malmesbury in 1911.

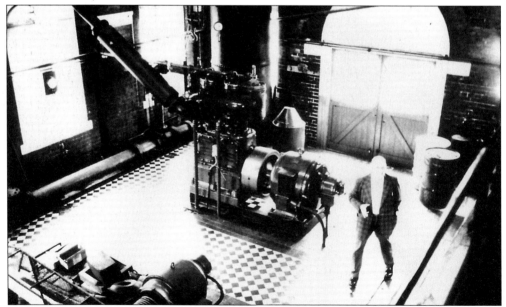

Mr Alan Vick, the superintendent, amongst the compressors and ejectors within the Pump House. In 1961 an automatic pump was installed underground (by the shelter at the corner of Wick Lane). No machinery remains as a reminder, as the building was converted to offices on becoming redundant.

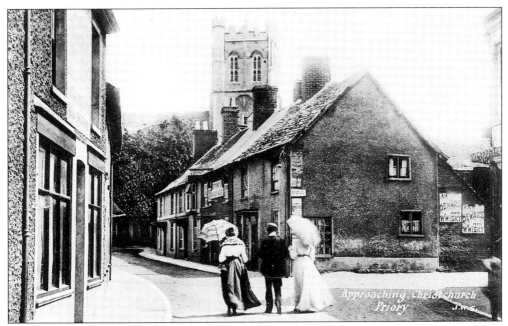

Church Street, *c.* 1906. This dating is supported by the presence of the end house in this medieval row, demolished at about this time. On the wall, in sharp contrast to the ancient cottages, the very recent innovation of a motor boat (Christchurch Motor Boat Company was established at Wick Ferry in 1906) is advertised. The hanging sign indicates the Eight Bells public house ('Strong's Romsey Ales'), which ceased trading in 1907 after well over 200 years. In 1911 the proprietress of the Priory Tea House, the edge of which is just visible on the right, ironically bore the name of Mrs Beer.

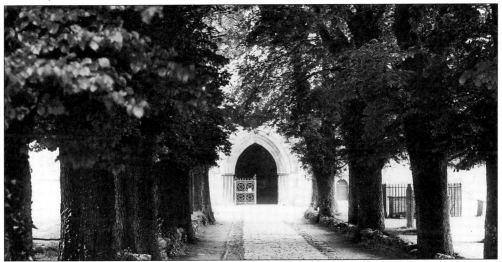

The Elm Avenue. This graceful and dignified approach to the north porch of the Priory Church comprised trees said to have been planted in 1780. Concern for their condition led to a report being obtained in 1934 from Kew Gardens, which found extensive decay and recommended replacements be planted. One of the trees had died by 1955 and eventually they were all felled. Note the stone walls between each tree and the ironwork around George Holloway's tomb, all now vanished along with the elms.

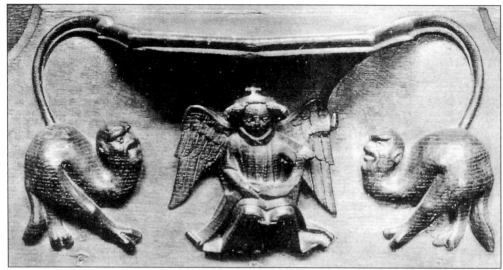

The Misereries. These medieval carvings, under the choir seats in the Priory Church, have long been the subject of academic speculation. Each of them is different and one is thought to be as old as about 1200. They have been variously explained as satire against political figures; examples from the Bestiaries of the Middle Ages; and illustrations of fables and legends. Some authorities found them shocking: 'It must be deplored that their introduction into a building consecrated to religious observances should have been sanctioned.' (1837 guide book)

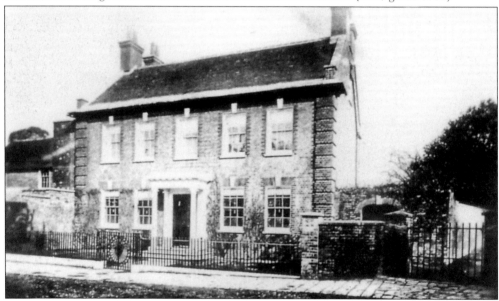

Church Hatch. This early-eighteenth-century house was saved in 1929 from conversion to shops, with housing in the grounds, by the intervention of Revd W.H. Gay, Alan Druitt, Frank Ricardo and Sir G.L.T.G. Meyrick Bart., who established a trust to purchase it by a public appeal. It has been the home of many prominent people, including Sir Owen Tudor Burne from 1903-9 (from which period the picture dates), soldier and statesman, veteran of the Crimea and Secretary to three successive Viceroys of India; and the publisher Walter Hutchinson in the 1930s, who installed the first direct telephone line from Christchurch to his London headquarters.

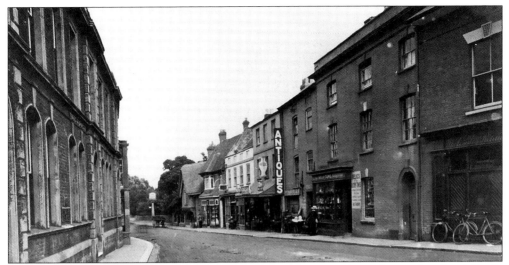

Councillor Henry Frederick Hope created an antiques empire along the south side of Castle Street - with offshoots elsewhere in the town - from just before the First World War until his death in 1928. The central building was used from around 1855 to 1922 by Charles Reeks, cornfactor; the sack hoist can be seen above the top-storey window. The large display window appears formerly to have been a coach entrance. 'Relics of Olden Times', proclaims the sign adjacent to this window, the contents of which have attracted the attention of a young mother passing by.

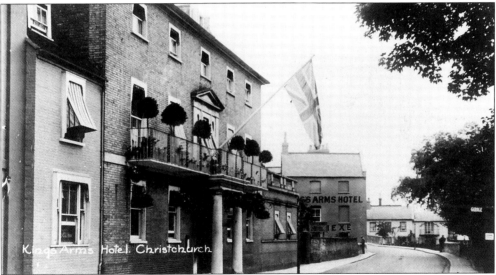

Built in 1801-3 as Humby's on the site of a seventeenth-century inn of the same name, the King's Arms has been extended several times, most interestingly in 1936, when the ballroom was built around an ancient timber-framed structure. It has been the venue for clubs and societies of every description: the Twyneham Lodge of Freemasons, Rotary Club, Music Society and Round Table, amongst others. The medieval court leet was revived here in 1915, at which the mayor was sworn in and other manorial officials appointed, such as the aletaster, hayward and bailiff. Subsidence forced its temporary closure in 1985 to enable the frontage to be entirely rebuilt. In 2007 permission was granted for extensive redevelopment of the hotel car park with blocks of flats and a large bistro.

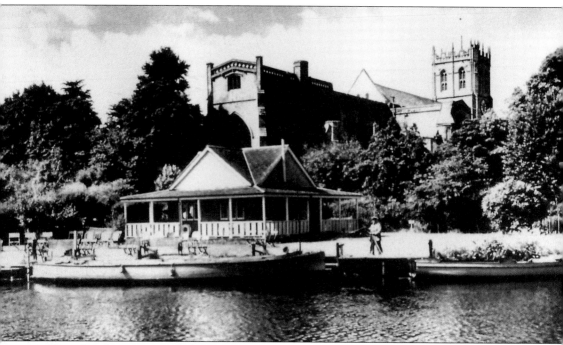

Christchurch Priory, and the Convent Walk Tea Gardens, created in 1926. The idyllic Convent Meadow was once open to the public; in 1922 Herbert Druitt tried unsuccessfully to purchase it for the town in order to preserve the view from the Town Bridge. In 1963 the tea house was indeed replaced by a house and his concern proved to be well founded. The tea house is seen here in the 1940s when run by the Beedle family; Tony Beedle offered boat trips around the harbour. One of his boats, the *Lady of Avon*, was used in the evacuation of Dunkirk, and another, the *Venture*, was the first boat to have a Hotchkiss Internal Cone Propeller for negotiating shallow water.

One of the boat drivers standing at the entrance to the Convent Walk Tea Gardens by the Gin Door. The huge cedar tree came down in a storm.

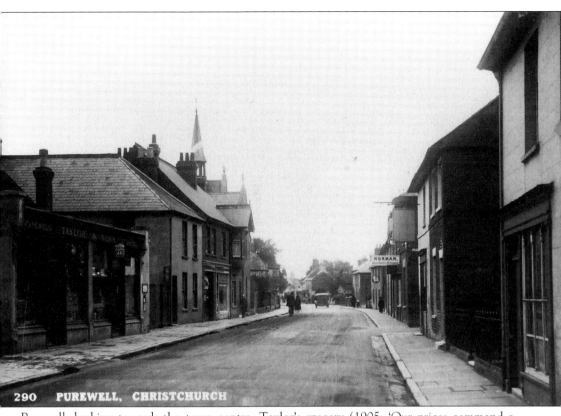

Purewell, looking towards the town centre. Taylor's grocery (1905: 'Our prices command a ready sale') established around 1865 is on the left. Opposite it the sign for Norman's Cycle Dealers and Repairers hangs on the house at one corner of the narrow entrance into Livingstone Road, which was known as Park Place until about 1890. The hanging sign marks a public house, the Stag, later known as the White Hart. The fact that only the board seems to remain indicates that the photograph dates from after 1916, when the inn closed after some thirty years trading; the style of the car in the distance suggests a few years had passed since then. St Joseph's church spire rises above the rooftops: another vanished sight.

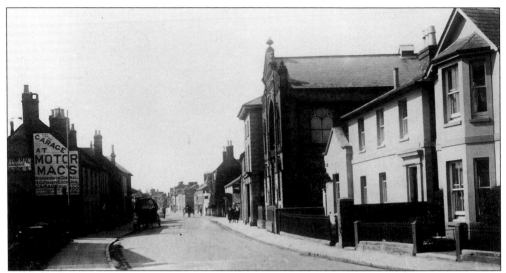

Purewell again, nearer the Stony Lane junction, showing the former Wesleyan chapel, now a snooker hall, after being rebuilt in 1890. Wesleyism arrived with the Cornishmen working on the first Highcliffe Castle and in 1932 was amalgamated with Methodism. Thereafter, the building was used briefly as the Escor Toy Factory. The house to its right no longer exists. It was the home in the early Victorian years, of a leather-currier and cutter called Edward Mintern, later becoming the home of a surgeon, John Hodgkinson. Motor Mac's was a large garage in Bournemouth.

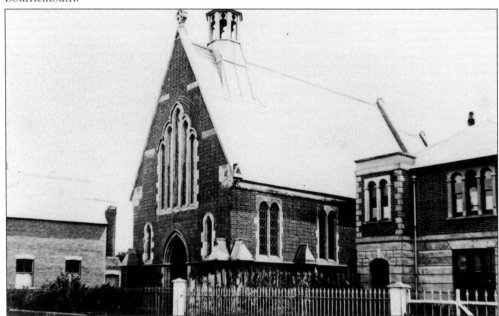

The Roman Catholic St Joseph's church of 1866. The principal fundraiser was also the first priest, the Belgian-born Bernard Van Reeth. The architect was J.E. Holloway, at the time responsible for the disastrous ironstone mining operation at Hengistbury Head. The spire was eventually found to be unsafe and replaced with a cupola and bell, but this in turn was removed in the 1950s. On the left the church school, opened in 1869, remained in use until the new school at Somerford was built in 1963. Note the house on the right, now a veterinary practice.

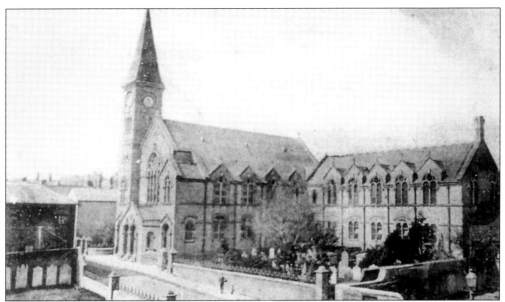

In the same year as the Roman Catholic church was completed, the Congregationalists replaced an earlier brick structure with this brick and stone church, seen here before 1905. Many prominent Christchurch families belonged, including those of Kemp Welch, Lane, Tice, Aldridge and Jenkins. The incumbent during the rebuilding, Revd Joseph Fletcher, helped found the *Christchurch Times* in 1855 and also ran a school in Hengistbury House. Seven of his pupils tragically died whilst bathing at Mudeford, after which he closed the school. In late Victorian times this church was a popular venue for a variety of exhibitions, societies, debates and entertainment.

Returning to the heart of the town, the Pit Site, partly cleared in stages from the late nineteenth century and completely removed in the 1950s, was an overcrowded hotch-potch of cottages with a rather chaotic street pattern and the scene of several major fire disasters, notably in 1825 and again forty years later. It cannot have been much help that the well was frequently blocked and water had to be fetched from the river. Tucked away behind the former Cross Keys public house on the Barrack Road frontage, the house shown above was the home of Mrs Olive Norman (pictured) and appears to have been thatched.

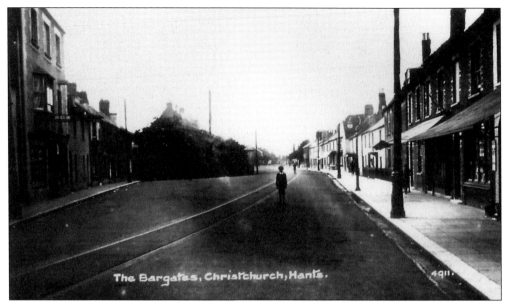

The Bargates, Christchurch, Hants.

The Pit Site (old gravel pits), faced a part of Bargates known as West End, just north of Pound Lane. In the 1930s an elderly Bargates resident recalled a cattle market in his youth at this point (remembering the annual fairs). The tram lines date the picture to post-1905. The trams came from Bournemouth via Tuckton Bridge and along Stour Road before turning into Bargates and on through the town to the terminus in Church Street. Surprisingly, there was no tram service along Barrack Road, which was not such a major thoroughfare as it is today.

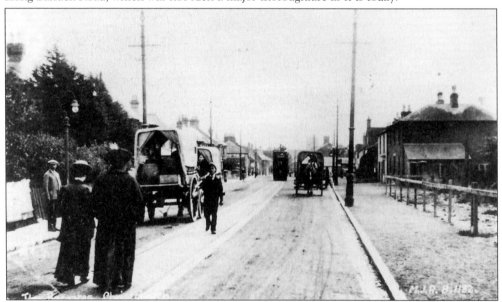

Bargates at a similar date to the above, but looking towards the town and featuring an interesting mix of transport. The first cottage on the right is now unrecognisable, as Castle's ironmongers, but at the time it was a farm tenanted by Charles Kerley until his death in 1920. The open space is the yard of a huge barn (out of view), by then in a ruinous state. It was measured by Herbert Druitt and found to be 51 ft long. Both properties were formerly owned by the medieval Hospital of St Mary Magdalen.

Magdalen Lane, *c.* 1910. The medieval hospital from which it got its name was probably sited at the junction with Barrack Road, on the left, and was a sanctuary for 'lepers' (which could describe various skin complaints) built outside the town walls and which disappeared centuries ago. The charity, with the income from its endowments, still functions some seven centuries after its earliest surviving documents. Note the prolific vegetation, the railings that were scrapped during the last war and the gate onto the main road, which remained until 1984.

Shortwood House, Magdalen Lane, *c.* 1905. Nearly 300 acres of common land known as Portfield were released for building by an Enclosure Award of 1878. The lane was created in consequence and four substantial villas were constructed. Here, from 1912-38, lived Mr F.E. Abbott, solicitor, twice mayor, and county councillor. His father-in-law, Frank Brooks, a brilliant portrait artist who had a studio in the grounds, painted the last portrait of King George V before his death. In 1940 the houses, with Shortwood as the HQ, were briefly requisitioned for Commander Montgomery (later Field-Marshal) of the 3rd Division and his troops, 'Monty's Diehards'.

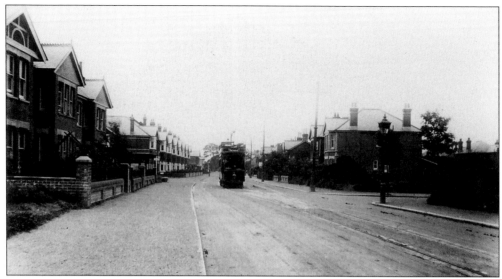

Stour Road, *c.* 1920s, looking towards Tuckton Bridge. Another consequence of the enclosure of Portfield was the closing of ancient lanes and the laying out of modern roads, e.g. Stour Road, Jumpers Avenue and Portfield Road. Building did not commence immediately and it was many years before all the plots were occupied, but the standard of housing was a great advance on the tiny and often crowded cottages of earlier generations. This street is unusually wide, as the commissioner for some reason also awarded the strips along the edges to the townspeople for 'exercise and recreation', as with the recreation ground.

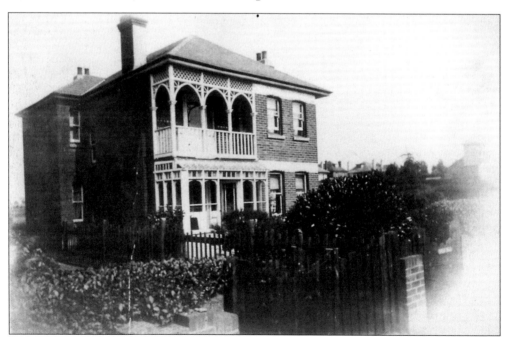

Stour Road. 'House built by my grandfather, 12 Stour Road, 1910/11, £500', says the note on the reverse, an example of the surprising amount of time which elapsed before the Stour Road plots were filled. For thirty-odd years the land had remained vacant, and its rural character is still evident here. Next door the plot appears vacant still. The house remains, unaltered.

This page features two more houses filling the vacant plots in Stour Road. This is Thickthorne in 1909, at the corner of Arthur Road, occupied by William Butler, for thirty years a tailor for Ferrey's. The sender, by the name of Tarrant, lived at Twynham House, just a couple of doors away, an example of how localised such cards could be. Thickthorne is listed as a guest house in 1933 and is still with us, but the attractive brickwork is obscured by stone cladding and the original windows have been replaced, with the loss of much of its harmonious period feel.

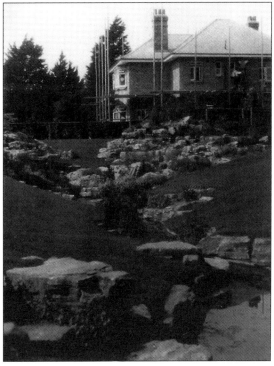

Dinmore, one of the houses built on Stour Road, at the corner of Barrack Road. This was taken in 1927 during construction and shows the cascading waterfall and rockery, now the site of a doctor's practice. The landscaping was apt, since this was to be the home of David Llewellyn OBE JP, county councillor, manager and engineer, then secretary and director, of the West Hants Water Company between 1911 and 1952, tireless supporter of many public causes and the anonymous donor of the bandstand on the Quay - given to commemorate the 1937 Coronation. Dinmore now has a third storey and houses a chiropractor.

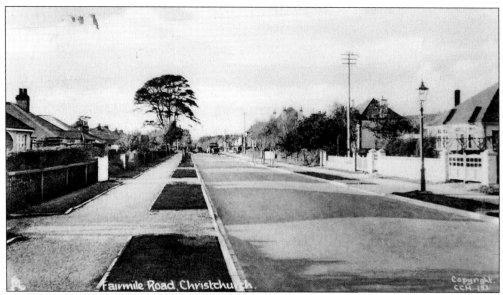

Fairmile, *c.* 1930. The spread of the town ('How our Borough grows' in the proud words of the local newspaper) reached this former country lane at this time. The laying out of the district was carefully planned by the South Coast Land Society, as can be seen from the neat verges and newly planted trees. Our newspaper editor was not amused by the sudden appearance of heavy hoof marks and cart tracks on the new turf - not everyone respected the suburbanisation!

Grove Lane formed part of Jumpers Common and was originally in Hurn parish. The 100 ft fir at the junction with Fairmile was an admired landmark and thought to be a 200 year old survivor of ancient forest. The remaining woods were being developed in the 1920s. Damaged by a gale in 1954, the noble tree had to be felled. Bungalows have crept onto the edges of this lonely lane, foreshadowing road widening (by some 16 ft), in 1936. Grove Farm itself is of historic interest, with features suggesting a late medieval origin. Bronze Age pottery finds indicate a site of great antiquity.

St Catherine's Hill. These isolated mud and thatch constructed cottages may well have been 'potboilers' cottages', which, if erected within 24 hours and with a fire going, gave the owner squatters' rights. Nevertheless, on two occasions aggrieved townspeople tried to tear them down, recalled one occupant, Henry Bendall, in 1927, whose father-in-law built one of them. A chapel on the hill, used from around the eleventh century, was dedicated to St Catherine, hence the name, but it was also known as 'Kattern's Hill'.

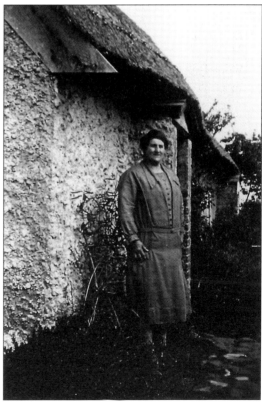

Agnes Tarrant outside her cottage. Note the rudimentary building materials. A Mrs Tarrant is listed as a tenant in the sale of Lord Malmesbury's land in 1919, which included this area. At that time a dozen or so cottages could be found; a few remain tucked away, seeming an anachronism in a hectic world. Occupiers would have had few home comforts: water was obtainable from one communal well and sanitation was non-existent. Local historian Donovan Lane recorded that some occupants were entitled to remain only during the life of the person who built the cottage.

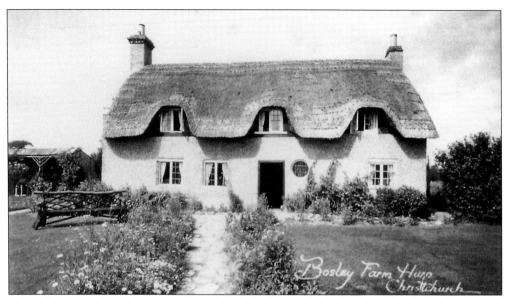

Bosley Farm, also formerly in Hurn parish. It is said that a house has stood on this site since 985 AD and this present one lays claim to being the oldest house in Christchurch. For many centuries it was a working farm. At the time of this photograph in the 1920s or '30s, it was a tea garden, and the encroachment of suburbia into its fields was under way. After the last war it gradually deteriorated but was rescued from complete dereliction and restored. It is now a listed building.

Whitefield, on Roeshot Hill. This house, which stood near the present petrol station in Lyndhurst Road, appeared in the 1890s and the photograph seems to have been taken around this time. It is included here on account of its name, which is a survival of an early field name, Roeshot Whitefields. Such names were handed down over the centuries in an agrarian community but nearly always disappeared after the industrial revolution, this one just surviving into the twentieth century.

Two

Transport

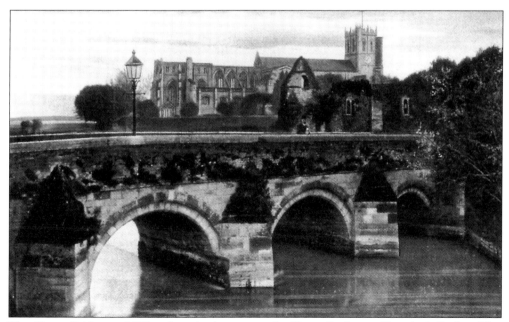

The Town Bridge, c. 1900, otherwise known as the Great Bridge or Quartley's Bridge. This scene, of the majestic Priory church dominating the skyline and the ivy-clad ruins of the Constable's House to the front of it, has been described as the finest in the south of England.

Wick Ferry, c. 1930. This was an ancient mode of transport supplemented by a nearby ford across the Stour from the end of Sopers Lane, which was used by horse-drawn farm wagons. Those who would have found the ferry essential included schoolchildren from Wick coming to the Priory School and Christchurch men going the other way to work at the iron mining operations at the Head or at piggeries on 'Berkeley Hill' (modern Southbourne). The approach was over fields from the end of Wick Lane. This is the view from the opposite side. The tourism potential was later exploited to the full.

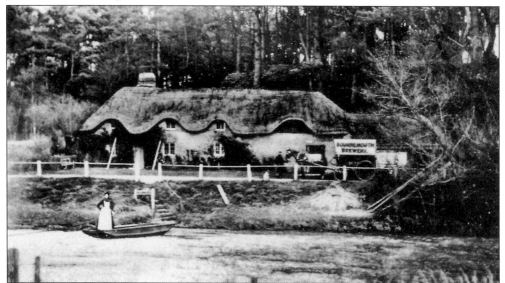

Blackwater Ferry. The charming subject of countless paintings and photographs, this postcard view from around 1900 is unusual in featuring a Bournemouth Brewery dray. Ferry Cottage was next to the Blackwater Cottages, but its site is now partly under the widened Hurn Road. Once it traded as an inn, but this was stopped by one of the Earls of Malmesbury, its owner, as he suspected it was the haunt of poachers. By the mid-1930s Ferry Cottage had fallen into dilapidation and gone: 'I cannot think how anyone could allow such a lovely place to become nothing but a memory', was an appropriate lament.

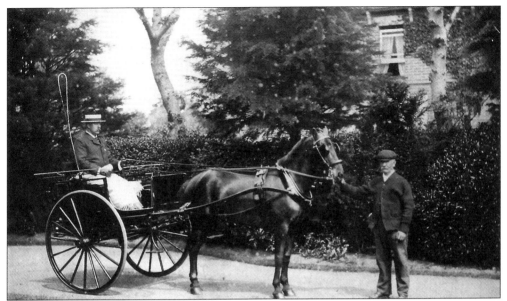

Mr Thomas, cartage contractor, of Shortwood House, Magdalen Lane, and Croucher, *c*. 1905. Croucher was the coachman for Henry West Jenkins, of Riversdale in the lane, sometime mayor and lay preacher. All the houses in Magdalen Lane had coach houses. Mr Jenkins was remembered as 'a marvellous man' who used to reach Cranemoor chapel to preach every Sunday by his horse-drawn dog cart. Maybe this is the very one. Both horse and cart look beautifully cared for.

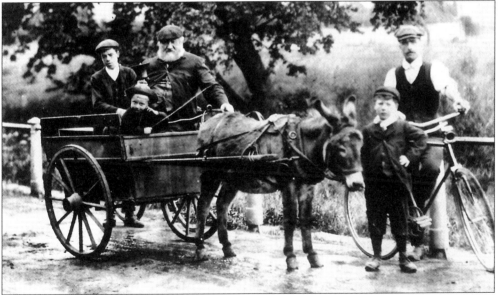

Donkey and cart. This more basic mode of transport carries Joseph Cave Preston, who was, from the 1870s, the last town crier, an important function before phones and radios. This office has been resurrected as a visitor attraction in recent years. He lived in Spicer Street, on the Pit Site, and died in 1922, reduced to this method of travel by infirmity late in life. A Mr Butler holds the bicycle and the standing boy is Dan Preston. The other boy in the cart is Jack Tarrant. The lad behind has not been identified.

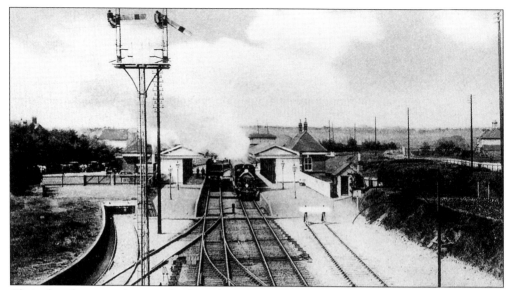

Christchurch station, but not the first: that was constructed in 1862 and situated on the other side of Fairmile Bridge. The direct line to London opened in 1883 and, judging from the rural surroundings, this is an early photograph of it. The set of rails curving across to the right led to the original line; that on the left was a siding of which traces remain. Before rail reached the town, travellers had to pick up the 'horse bus', a small phaeton, to Holmsley and then endure a rail journey of some five hours' duration. The last train on the Ringwood line ran in 1935.

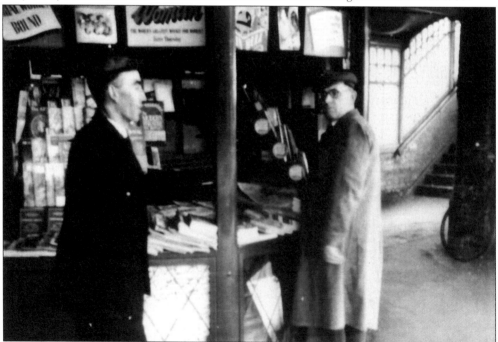

The station kiosk. Improvements in rail travel, such as this newspaper kiosk in the 1950s, used to alleviate the boredom and hunger pangs of prospective travellers. Ted Dance is on the left and Arthur Clark on the right. Note another vanished feature - the glazing alongside the passenger footbridge.

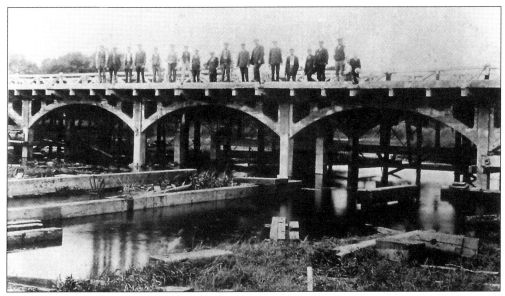

The first Tuckton Bridge of 1882 must have been a huge advance on the previous means of crossing the Stour - by Wick Ferry or all the way to the old Iford Bridge. The Tuckton Bridge Company was formed in 1881 by the founder of Southbourne, Dr Compton, and the bridge was a toll bridge, as was its successor. As it was only a wooden structure it had to be replaced to take the trams just over twenty years later. The photograph appears to show the construction gang peering down at sizeable offcuts of timber in the river below.

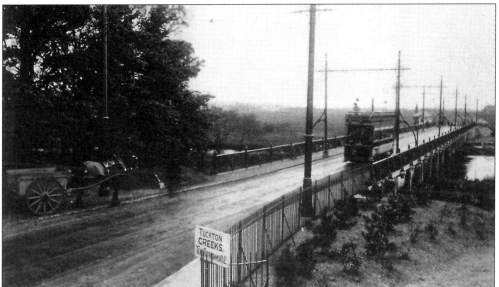

The second bridge, soon after opening in 1905 after being rebuilt to carry the trams, one of which trundles over from the Christchurch side, keeping a brass-bedecked horse and its cart patiently waiting on the near side. There is a remarkable absence of development on either side. The bridge was thoroughly tested in advance of opening, with two tramcars each with a 16 ton load, plus several tons of cement to represent the passengers' weight. A deflection of a mere $9\frac{1}{8}$ in testified to the skill of the engineers. In the middle distance, the large house known as Homelands can just be made out.

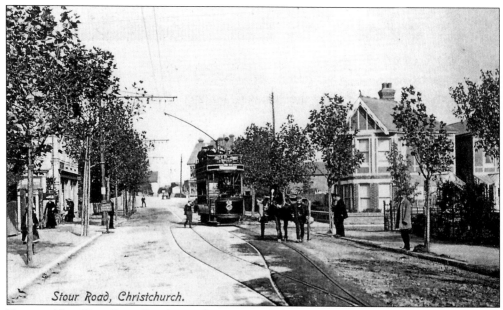

Stour Road, Christchurch.

Tramcar No. 45 in Stour Road near Station Road, from a card postmarked 1906. Its number indicates that it was one of the first batch of trams supplied at the opening of the Bournemouth tramway system in 1902, and it would have been painted in the maroon and yellow livery of the Bournemouth Corporation Tramways. Note the loop by which means trams were able to pass each other and the sign on the left warning of a steam roller working ahead, probably at Light and Co's timber yard ahead.

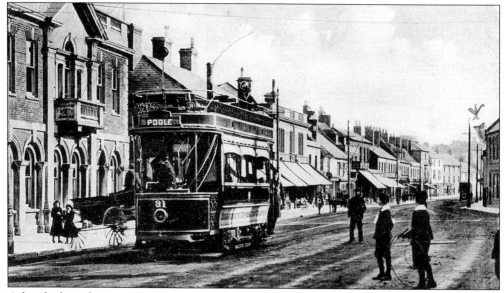

A last look at the tram, 1905-1936. This is another of the first batch of trams, the arrival of which had a dramatic effect on property prices of houses on the route. Before long they were seen as noisy and unwieldy, bullying other road users with their domineering bulk. On their demise the bodies lived on in the form of various ingenious uses, the most ignominious being the fate of the inaugural mayoral tram which suffered the indignity of becoming a humble trolley bus waiting room at Iford until 1952.

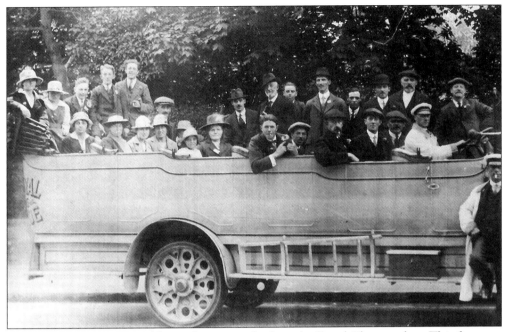

A charabanc, *c.* 1930. Visible on the rear is the logo for Royal Blue coaches. This firm was started by the Elliott brothers in 1880 with horse-drawn wagons. It was taken over in 1935 by the Hants and Dorset Bus Company, which kept this logo for a considerable time afterwards. Charabancs were immensely popular and Christchurch, being a tourist town, was invaded by them. For the occupants of this specimen it looked like an enjoyable experience.

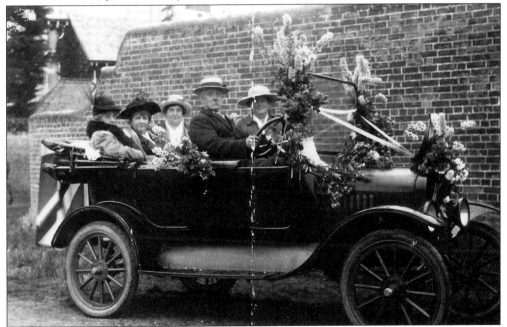

This gaily decorated car is thought to have belonged to a Mr Weavers, of Whangarie, 8 Stour Road, and was decked up for an excursion to a fete. It is a Model T Ford, identified by its pressed-steel radiator as being manufactured in 1917. Mr Weavers was a councillor in 1919.

Church Street in 1957, showing a trolley bus peeping out of the yard behind the Dolphin Inn, where it would have been turned manually on the turntable. Although the inn has gone, the turntable remains, a listed structure and thought to be the only one remaining in England. These vehicles demanded a plethora of overhead wires strung on a thicket of poles, painted green. The number of tea shops in evidence is a reminder that Church Street was nicknamed 'Meringue Alley'. (Courtesy of the Francis Frith Collection)

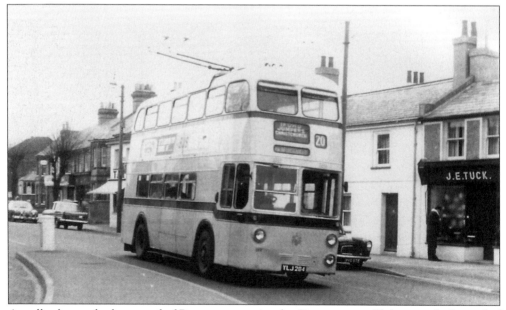

A trolley bus at the lower end of Bargates, opposite the Conservative Club, towards the end of the trolley bus era. The service ceased in 1969.

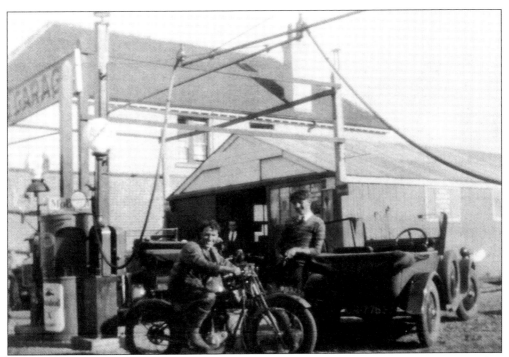

Another road with a nickname was Barrack Road, bristling with what the local paper referred to as 'serried rows' of petrol pumps and known therefore as 'Pump Alley' before the last war. The Studland Motor Depot at the foot of the railway bridge is selling 'Pratt's motor spirit'. The excitement of the early motoring era is captured in the expression in the (unhelmeted) rider's face, proudly astride his Rudge motorbike. Below is another enthusiast on a Coventry Eagle. Beyond is The White Hart Hotel before it was remodelled, with a row of posters alongside. It was demolished in the mid-1990s.

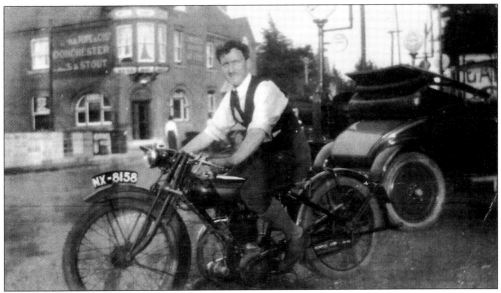

An early car on the approach to Barrack Road railway bridge. This was built with the advent of the railway, at which time the road was a narrow minor highway leading to the little village of Iford. The White Hart nearby was once an isolated coaching inn with only the barracks beyond until Iford. Bargates was, in fact, wider than Barrack Road until that was widened to four lanes in 1960.

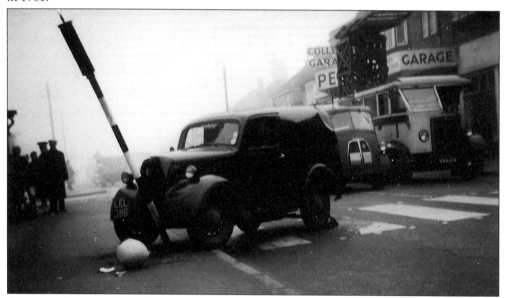

A car accident on a foggy January day in 1959: the inevitable corollary to the increase in car ownership. Taken outside the former Collett's Garage in Barrack Road, the calamity has attracted a group of curious onlookers. Some interesting vehicles are recorded, including a Bournemouth Corporation Transport overhead wagon used to repair trolley bus cables. Belisha beacons arrived in the town in 1939 and were occasionally stolen, such was their novelty value. This one has been 'decapitated' by the impact, but the light dutifully shines on through the gloom.

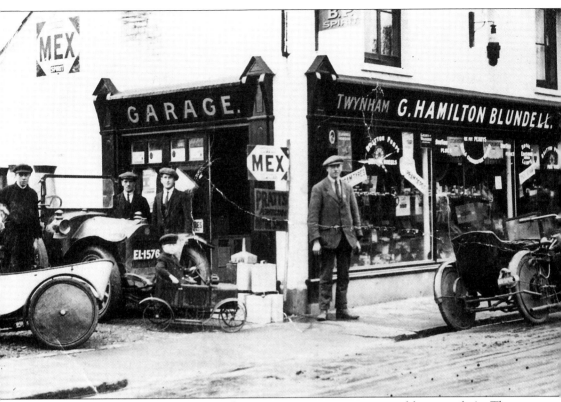

The Twynham Garage, Bridge Street; the premises are now a curtain fabric retailer's. The motorcycle combination on the road is an American 'Indian motocycle' from about 1918. The pedal car is typical of models that early garage workshops could put together themselves. On the left is a sidecar with a metal cover fitted to protect the spokes from mud. In the 1920s Hamilton Blundell boasted the installation of a roadside petrol pump, and claimed to be 'open day and night'. Amongst a selection of vehicles available for hire were 'landaulettes', which had folding hoods behind the rear seat (as does the one on facing page). Another facility offered was 'Heavy Haulage by 3-4 Ton Leyland Trucks'.

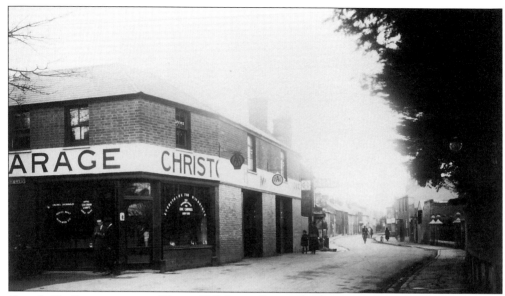

Campbell's Garage, corner of Scotts Hill Lane, Purewell. This evolved from a late nineteenth century 'carriage factory' which, by 1925, had become the Christchurch Motor Works. In 1927 the garage devised this new frontage to facilitate motors driving in plus 'latest types of towing ambulance and washing tank added'. The tree belonged to Hengistbury House, opposite. At this point it can be seen that the road curved considerably and, along with the Stony Lane corner, became an accident blackspot. It was straightened out in 1936, taking in some 10 feet of the house's curtilage.

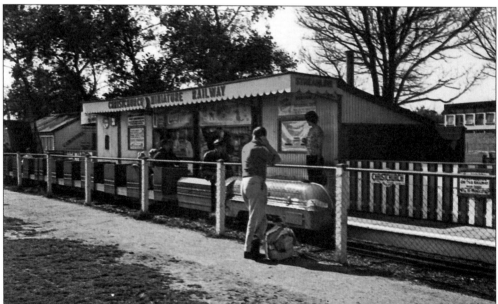

The model railway on Mayor's Mead. Mayor's Mead, near Quomps, derives its name from the medieval obligation to send the first cut of hay from it to the mayor to defray his expenses. The spirit of this tradition was continued when permission was granted for siting this attraction here in 1949, as the council demanded 25 per cent of the profits in lieu of rent. This amusement remained long after its initial 5 year lease, a familiar site into the 1980s.

Three
At Work

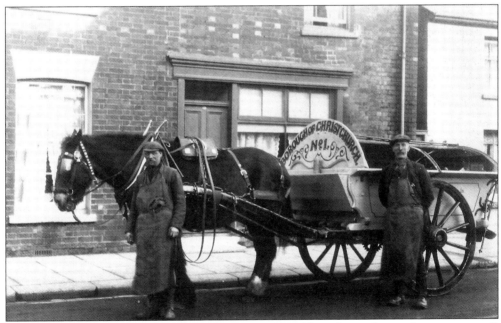

A municipal dustcart pausing on its rounds, *c.* 1918. These horse-drawn dustcarts are still remembered by older people who as children enjoyed hitching lifts by hanging on the back! The gentleman by the horse has been identified as Archie Keffen.

Creedy Fields in the 1930s, showing the view over the wall seen on page 14. McArdle's Wick Lane Farm was one of many Christchurch farms prior to the Second World War; others included Latch Farm, Purewell Farm, Mudeford Farm, Dudsbury Farm, Newman's Farm (Fairmile), Grove Farm and Stanpit Farm. Mr McArdle cannily diversified into the growing leisure industry, letting these fields out to holidaying campers. During the war the land was pressed into service in the Dig for Victory campaign. With the end of the war, farming ceased altogether and the Wickfield estate, commenced before the war began, was completed.

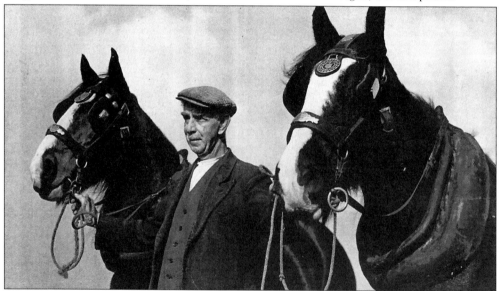

The South Avon and Stour Agricultural Society. Charlie White stands proudly holding the reins of his shire horses, having become once more the Champion Ploughman at the annual ploughing match held in October at one of the local farms. This society was formed in 1794, and horse ploughing was the finale of the competitions until the last entries with horses in 1953, rendering Mr White's skills redundant. The tractor, capable of working at six times the speed of the horses, revolutionised a way of life and farming practices little changed in centuries.

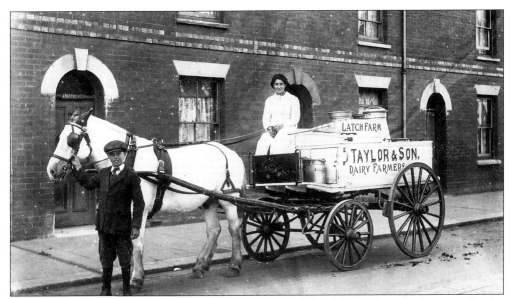

Taylor's Dairy, *c.* 1920. Harold Perry holds the reins of the delivery dray for his sister Bertha outside No. 78 Bargates, opposite the bottling plant where the horses were kept at the corner of Fairfield. Latch Farm, which had more than 300 acres when sold in 1866, was long farmed by Sidney Taylor, who also had a retail outlet for his Channel Island milk in the High Street (see page 11). Taylor's Dairy ('You can whip our cream but you can't beat our milk') was acquired in 1938 by Malmesbury and Parsons, which in turn was absorbed by Unigate.

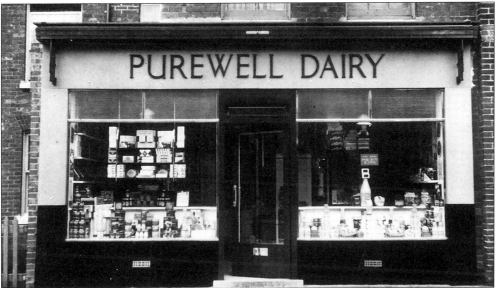

Purewell Dairy. At one time this belonged to Purewell Farm and both were run from around 1890 by Charles Selby, who supplied an alternative beverage as landlord of the Stag (see page 21). Fred Gray followed him in about 1923, followed in 1931 by Edwards and Son. In 1939 William Fisher is listed as the occupant, when it doubled as a grocery. Like Latch Farm, it eventually passed into the Malmesbury and Parsons empire. Demolished in 1960, the site was empty for many years until the Buttery was built in its place. A jug from the dairy is in the Red House Museum.

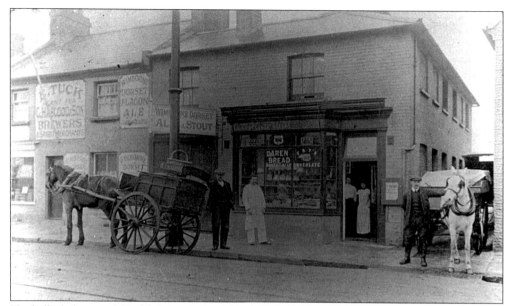

Hayball's bakery and Tuck's brewery, *c.* 1908, lower Bargates. In 1913 Mr A.S. Hayball bought the business, which commenced in 1903, from his employer, Mr Woodford (name over the door). Hayball's became prize-winning master bakers, specialising in confectionery. Either cart may well be the same one that was still in use until 1966, the last example of commercial horse transport in the town, only ceasing when farriers became scarce. The sign at Tuck's reads: 'Agent for G. Habgood & Son, brewers and Spirit Merchants. Wimborne Dorset Flagon Ale'. This was the London Brewery, now part of the Highlander nightclub.

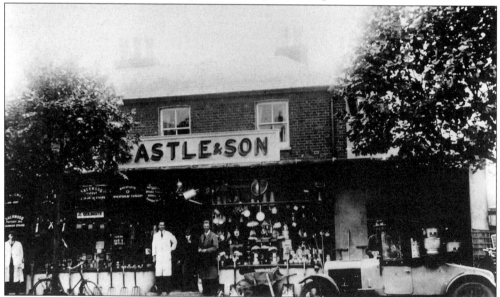

Castle and Sons. The former Home Farm, Bargates, was acquired in 1923 by a Mr Castle and converted from a three-bedroom brick house to an ironmonger's, still thriving today. The farm was at one time in the ownership of the Hospital of St Mary Magdalen, and at the time of the sale the farmland extended to Barrack Road. The interior testifies to considerable age, with some stone-flagged floors remaining inside and staddle stones outside.

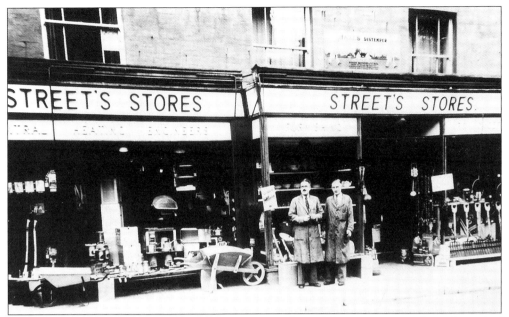

Street's Stores, Castle Street, were almost continuously used for ironmongery from the end of the seventeenth century until around 1961. Once a blacksmith's forge and tinsmith's workshop, ironmongery proper commenced with one Henry Farmer in about 1850 and soon afterwards passed to John Street. His son, Alfred, had another shop in the High Street and there was a further branch in Boscombe. Pigeons were used to carry messages between the shops before the last war. A huge range of domestic and garden equipment was carried, as the picture shows.

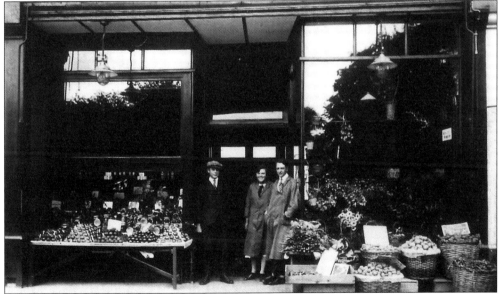

Priory Fruit Stores, Castle Street. Mr Ernest Elliott, proprietor, on the right, stands with his sister, Dolly, outside his gleaming greengrocery in 1922. Well over fifty years later the business was still trading, but its current use as a fashionable ladies' clothing shop is very different. The use of wicker baskets for the produce, propped up on orange boxes and trestles, adds an appropriately rural touch.

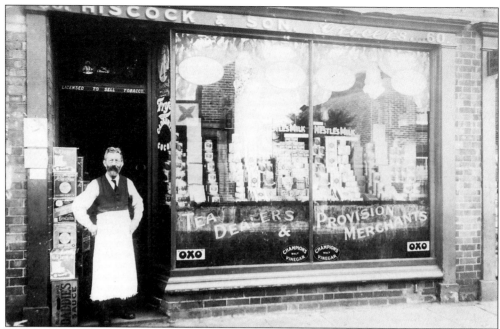

Hiscock and Son. Mr Edward ('Ted') Hiscock appears in the directories at No. 60 Purewell (now No. 111) in 1896 as a grocer and provision merchant, but the appearance of a 'Hiscock and Son' in a 1926 directory indicates that this is around the date of the photograph. Presumably, this 'Ted' Hiscock is the gentleman in the doorway. An advert in 1916 claims that the business was established 120 years before, quite a record, but another branch was sited at the 'tram terminus', in Church Street. Mr Hiscock died in 1942.

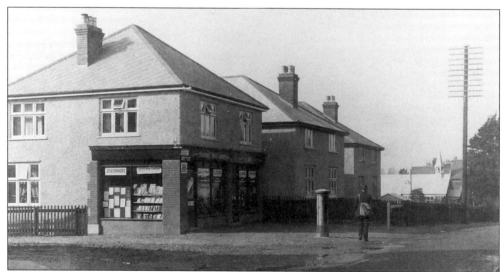

The Stourvale Post Office, Barrack Road. Four collections a day and one on Sundays was an impressive service over 90 years ago from this sub-post office in the new district of Stourvale. Not long ago the pillar box was removed to the civic offices and painted brown; an explanatory plaque informs the user that it dates from the reign of Edward VII. The state of the road leaves much to be desired, being full of muddy puddles.

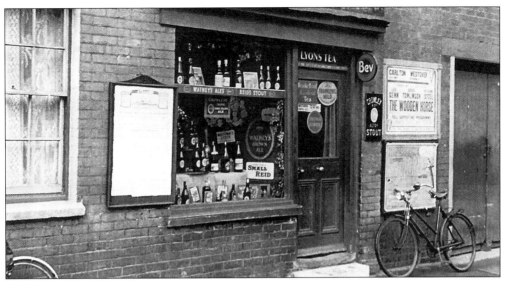

Off-licence, Bargates: the evolution of a shop. The building illustrated on the front cover has been an off-licence through most of the twentieth century, originally for the Crowley's brewery of Romsey. The First World War photograph on the cover shows Mr and Mrs Charles Hibbs in the doorways. Their income was supplemented by accommodating touring cyclists. The occupancy changed in 1936 to Mr and Mrs Harold Perry. This view of it dates from around 1950, the film *The Wooden Horse* having been released in that year. The Perrys remained until 1961 and expanded the business from beers and ciders to wine and home-grown produce. By the time the new occupants, by the name of Effemy, took over, Watneys had acquired it and widened the shop front to incorporate one of the downstairs windows. The grocery business expanded: the shop displays cornflake packets and tins on the right. A close comparison between the photographs, which may be only ten years apart, reveals interesting details such as the removal of the well-worn step to the shop entrance. The shop has recently been converted to housing after nearly ninety years in the same trade.

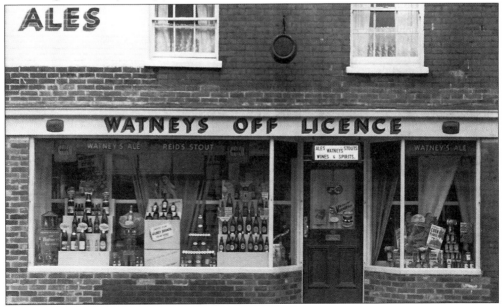

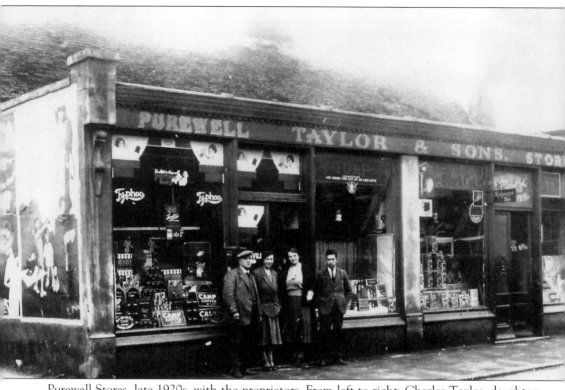

Purewell Stores, late 1920s, with the proprietors. From left to right: Charles Taylor, daughters Ellen and Harriet, and Leslie Dunster, standing outside as was the custom with shop photographs. The origin of the building as a cottage is clear from the clay-tiled roof; no roof is now visible. A Lumen Cottage is recorded on this site in 1836, in which lived Thomas Lyte, father of the hymn writer. Taylor's was established in 1865 and continued trading for several generations until 1932. It is now Purewell Electrical.

PUREWELL,

Christchurch, _Dec._ 18 69

M_r_.

Bought of H. J. TAYLOR,

TEA, COFFEE, SPICE & GENERAL GROCERY DEALER,

----------:0:---------

CHOICE BRITISH WINES.

Stonehenge Dairy briefly flourished at the corner of Jumpers Avenue, appearing first in 1928 in the ownership of Frederick Chilcott, dairyman, grocer and confectioner. Through the windows can be glimpsed a glorious assortment of nostalgic packets, including Carr's Biscuits, Saltzer Splits, Lyon's Cocoa, Saxa Salt, Rinso, Lifebuoy Soap and eggs in a Heinz 57 box. The boxes outside contain tins of mandarin oranges. Stonehenge Dairy did not trade for very long and has long since been converted into a house.

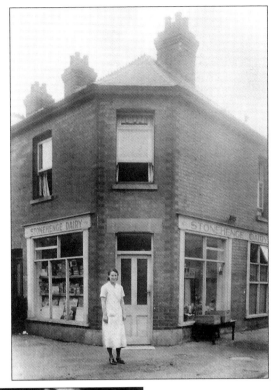

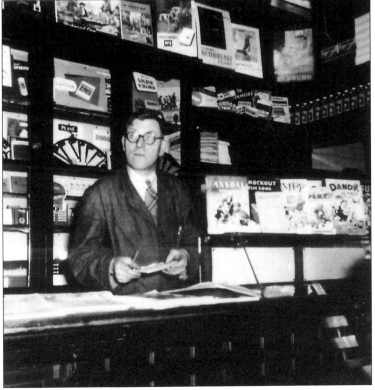

Inside Stedman's newsagent's in the 1950s, with Arthur Clark at the counter. His display includes some nostalgic-looking reading material popular with children in the age before television had lessened the appeal of comics. The bottles on the shelf would probably have been 'pop'. Behind Mr Clark are ranged neat rows of pipes and tobacco tins.

The Arts and Crafts shop at the former Eight Bells public house in Church Street - the last bottle of beer was drunk by nearby resident Charles Croucher in 1907. The name possibly derives from the seven original bells of the Priory Church: the stone flags on the floor bear witness to its great age. During the First World War the Arts and Crafts movement was flourishing in Christchurch, and this ancient cottage became its shop window. The proprietor, Edmund Veall, was instrumental in forming the Christchurch Group of artists.

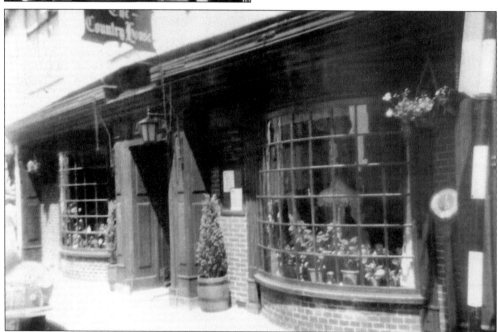

Also in Church Street but on the other side, was Mrs Berkeley's Country House restaurant. This was one of many such establishments on this approach to the Priory, whose proprietors were adept at waylaying tourists departing from the church. The Country House was established here in 1915 and survived well into the 1970s. It is now a public house (the Pig's Eye), but the frontage has been kept, intact.

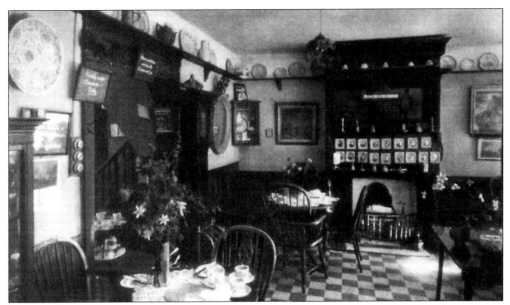

Next door to it, another tea room, the Olde Times, also thrived on the tourist trade. Many of these refreshment rooms specialised in selling meringues. This particular tea room is now the Castle Tavern.

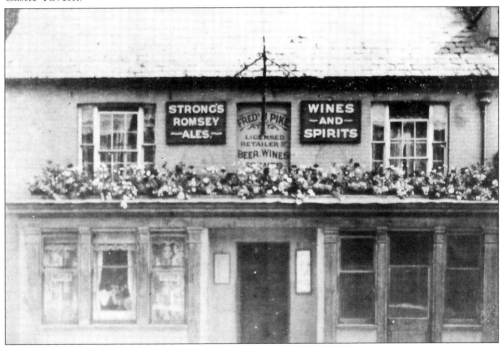

The Ship. In 1638 there was said to be only one tavern in the town, probably the George, earliest known reference to which is 1652; the Ship can be traced to 1688. By 1855 there were twenty-six inns and sixteen beerhouses. The Ship was always at the centre of local events; after corporation elections a hogshead of beer was distributed among the throng. Curiously, a German immigrant named Booz was landlord around 1895. Fred Pike is not listed in directories, but John Pike is, from 1907 or earlier until 1922.

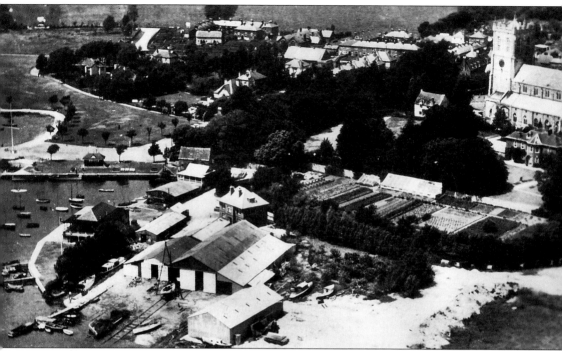

Elkins' boat yard (inter-war). In 1922, Mill Mead meadow was bought for boat-building and its level was raised by 4 ft. The yard constructed yachts, motor boats - for which was installed the first riverside petrol pump in the country - and dinghies. During the last war the yard was pressed into service for the Admiralty and produced an impressive number of support craft, a total of 220 specialised boats including 25 ft motor cutters and 72 ft harbour defence and landing craft. The allotments and greenhouse are now the part of the Priory grounds with the ornamental pond and pergola; note the undeveloped Creedy fields in the background, suggesting a date of the early 1930s for this photograph.

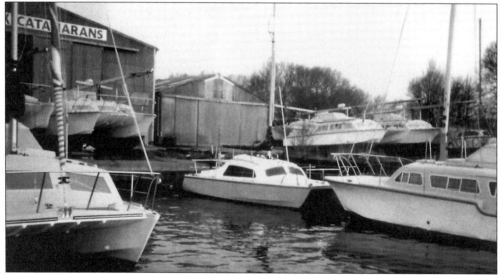

Tom Lack Catamarans, the last boat-building yard on the Quay on the site first occupied by Elkins', where today is a marina development. Tom Lack's closed in 1986.

View from Waterloo Bridge, probably during the late 1940s, showing the sign of Chas. Purbrook, old-established Christchurch builders of sailing craft, attached to what is now a private house. It is impossible to see Hengistbury Head from this spot today as the riverbank trees have flourished and the edge of the Civic Offices stands behind the poplars. In 1927 a Southampton firm bought Avon Wharf with the intention of using it to store vast quantities of petrol, to be delivered up the specially-dredged river by oil tankers. If that had materialised, this view would have been quite ruined.

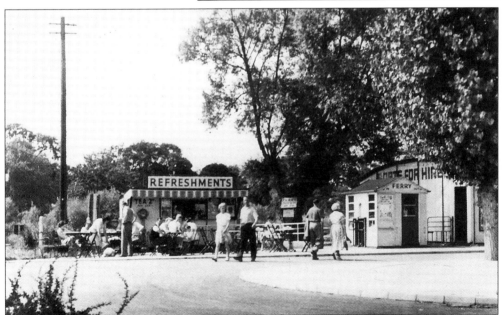

Wick Ferry Holiday Camp, c. 1960. The camping sites which originated with the Wick ferryman Mr J. Edmunds, and T.H. McArdle on his fields before the last war, steadily grew into a thriving holiday industry. They evolved into Pontin's holiday camp and currently trade as Manor Parcs. In this view the original ferry service, around which the business steadily grew, remains a principal attraction. (Courtesy of the Francis Frith Collection)

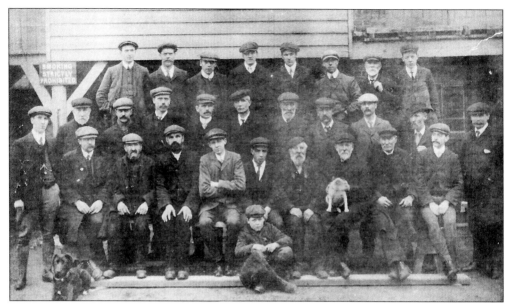

Light's timber yard, adjacent to the Fairmile Bridge in Bargates, on which a concrete yard is now sited. Light's took enormous tree trunks from the forest and elsewhere to these works by horsepower or steam traction, to be reduced to planks. Seen here in about 1906, the group of workmen plus pet dogs includes Tom Jonas, seated in the centre of the front row. He spent over thirty years of his working life with Light's as a 'saw-doctor', sharpening the massive saws used to cut the planks. Note the specimen plank on which their feet are resting.

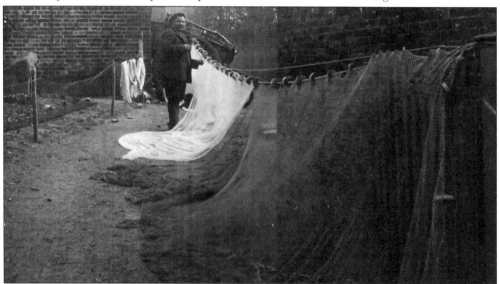

Fred Tarrant, rag and bone man, slaughterman and knacker, of 35 Bargates, in the 1920s, drying his hand-made fishing nets. Number 35 faced the old barn that stood until recently next to the Conservative Club. The garden was very long - right back to the millstream. Fred was so concerned that the Priory would be attacked by the Suffragettes that he valiantly guarded it all night every night until the risk passed. In the background a large cart is partly in view, made here too by Walter Preston. Mr Tarrant was a familiar figure in Christchurch; when he died in 1950 the crafts of his trade he practised passed with him.

Four
Education and Welfare

Priory School Sunday School, *c.* 1930, assembled for their annual outing. Miss Lagg is surrounded by (clockwise) Alan Vick, Alfie Brown, Bill Ashby, Jim Golby, George Ashby, Eric Bryant and Tom Collins. Most or all of the local churches had Sunday schools, the movement founded by Robert Raikes in 1780 in Gloucester.

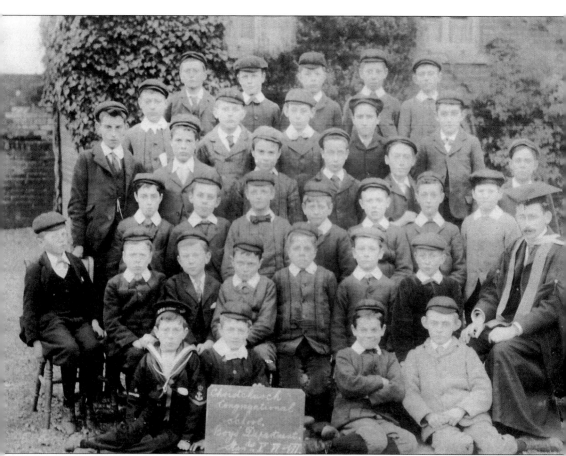

Congregational School, 21 January 1902. Standards V, VI and VII were for children aged approximately 10 to 12 years. These boys are pictured outside the 'Doll's House', now long disused, which was the accommodation for the master or mistress. It dates from the early 1830s, as does the adjoining school itself. The older pupils would have been taught at this time in the church lecture hall and the original school building reserved for infants and girls. These boys are smartly, almost uniformly dressed, with the curious exception of the front row naval enthusiast.

Opposite: Two classes of 1929 at the Priory School. Back row, from left to right: Billy Ashby, Dan Seymour, Bert Bradley, Lewis Langridge, George Ashby, Cliff Pardy, ? Howells, Wally Bennett, Len Young, Ronnie Bishop, -?-, Colin West, Peter Preston, Billy Wort, Roy Miller. Second row: Cath Staniforth, Lily Osmond, ? Gillard, Mary Bennett, ? Howells, Olive Godden, Elma Melly, Billy Brewer, John Wadsley, Alan Vick, Eric Bryant, Harold Baker, Alfie Brown, Len Wall, Billy Perry, ? Brewer, Dennis Head. Third row: Charlie Hendy, Doug Ford (seated), Cecil Weeks, Sammy Burton, ? Cox ?, Mary Kerley, Mary Troke, Helen Wright, ? Collins, Enid Cole, Celia Harrison, Nelly Croucher, Eileen Belbin. Seated: Pam Taylor, Ethel Holes. Front row: ? Saunders ?, Ronny Stevens, Tich Bradley, ? Gillingham, Hilda Hiscock, Nancy Payne, Gladys Cake, Joyce Reffen, ? Brewer, ? Rogers, Kenny McArdle, Jim Golby, Tom Ford.

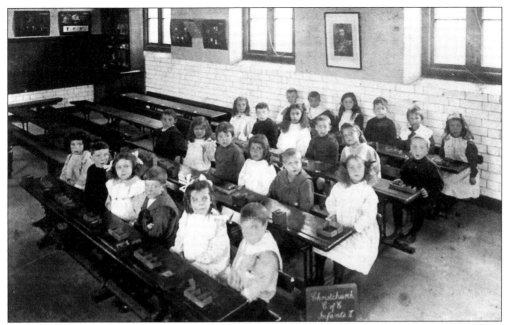

The Priory School, probably at the turn of the century. Above the blackboard are displays on bees and dandelions, probably part of an 'object lesson'. Constructed in 1867 as a National School by Joseph Lander for about £2,000 on a site given by General Lord Strathnairn and his brother Sir William Rose, in 1907 the school could accommodate around 600 children. National Schools were established by the Church of England in 1811, as opposed to the other system which was British Schools for the nonconformists.

Clonmanron School, *c.* 1920, a private kindergarten and preparatory school 'for girls and young boys', initially based in Bridge Street in the present Filer Knapper building and later at Autumn Gold at the corner of Barrack Road and Stour Road. The school began in the first few years of the twentieth century and continued until at least the last war. Four rather earnest-looking ladies, almost certainly the teachers, the Principal being a Miss Bell, form the centre of the group.

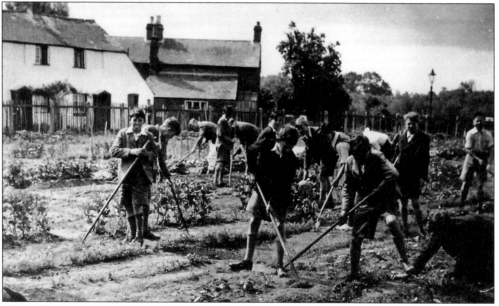

Christchurch Secondary School (now Twynham), 1948. Here is the gardening class busy cultivating part of the grounds. The school opened in 1930 in Sopers Lane and was the only secondary school until the opening of a grammar school in Highcliffe in 1963. Beyond, right, is Ferry Lodge, originally a mud and wattle cottage dating from around the eighteenth-century which was encased in brick in about 1883. In the wall were found farthing and halfpenny tokens from Lane and Lane, grocers, of Church Street.

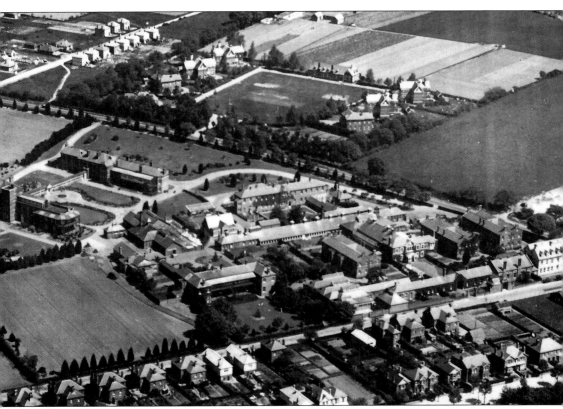

Christchurch Workhouse, c. 1935, in its prime before the advent of the welfare state in 1948, after which it became the town's hospital. This aerial photograph clearly shows the extensive range of buildings gradually added after its move to this site in 1881 from the earlier workhouse, which is now the Red House Museum. The extensive scale of the institution was accounted for by the inclusion of Bournemouth in the Union. On the other side of the Fairmile Road can be seen the Cottage Homes which housed the children and which are now the site of the Bronte estate. The excavations of a Bronze Age burial ground are visible in the next field, lately developed and named after the archaeologist, Bernard Calkin, and the type of urns unearthed, Rimbury-Deveril. Most of the workhouse site was lost to redevelopment in 1995.

Christchurch Union.

Union Workhouse.

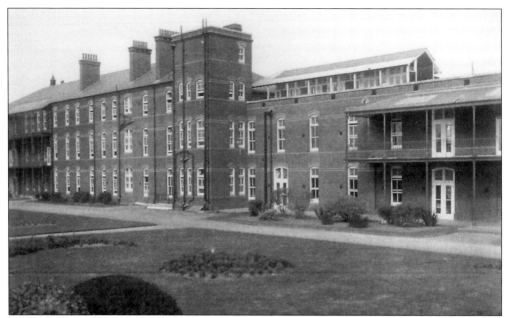

The Women's Infirmary. The last building constructed before the Board of Guardians was abolished in 1929, and now known by the stark name of G Block. On the roof are the TB shelters: outdoor treatment was standard practice for this disease before the development of antibiotics. It may come as a surprise to see how carefully the buildings and grounds were maintained in the workhouse era - a concern which was also generally extended to the inmates.

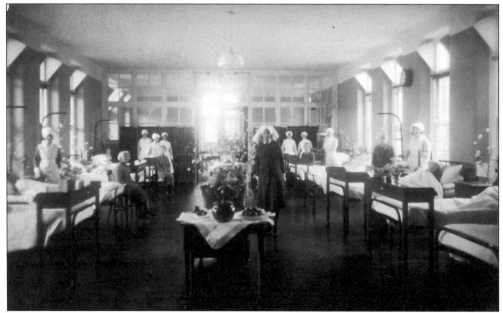

Interior of the Women's Infirmary, probably in the 1930s. This type of ward became known as a Nightingale ward - long and narrow with a row of beds either side. Everything looks spotless. The flooring is polished parquet, a feature removed on the grounds of hygiene in the hospital era. Bearing in mind that this was at the time a Poor Law institution, the care that has gone to brightening up the surroundings with flower arrangements is remarkable.

Five

Leisure

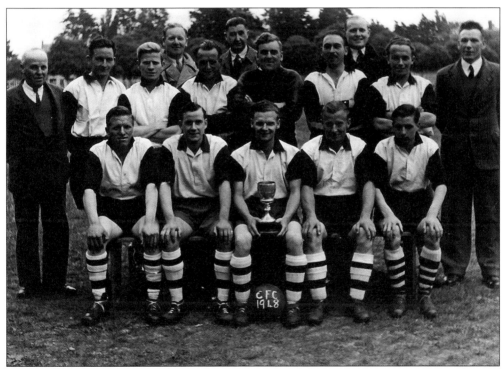

Christchurch Football Club 1948, in their black and white colours. Back row: Dan Preston, Wally Vey, Alan Vick. Middle row: Tommy Jonas, -?-, -?-, George Plowman, Les Green (goalkeeper), Alfie Brown, Don Seymour, Pat London. Front row: Eddie Reid, Michael Green, Henry Cox, Bob Tomkins, 'Chase' London.

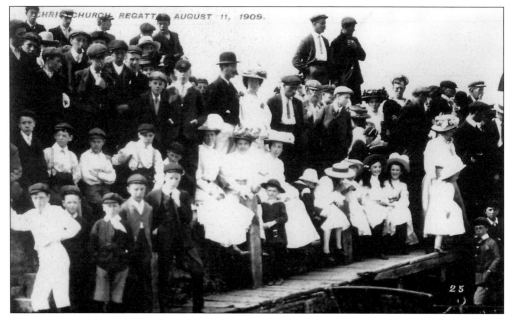

The Regatta, 1909. This was the first one held at the Quay after being transferred from Mudeford and it was a considerable success, despite clashing with that of Bournemouth. 5,000 people were said to have attended and enjoyed fine weather, as can be seen. The races involved different sections of the community, such as the local fishermen and the soldiers at the Barracks and at Bure Camp, and were not confined to orthodox events. A tug-of-war from punts must have given much amusement, as must the barrel race, greasy pole race and the Catastrophe Race.

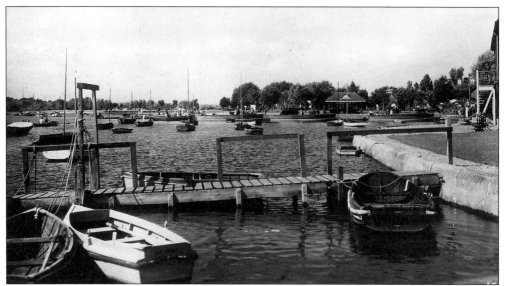

Boating, possibly in the 1930s judging from this view of the busy area in front of the Sailing Club, from which the jetty, long since disappeared, provides a walkway to an assortment of boats. In the distance three excursion boats can be seen at the Quay. These would have been destined either for Mudeford sandspit or Tuckton Tea gardens, much as today. A few cars of the period have parked either side of the shelter.

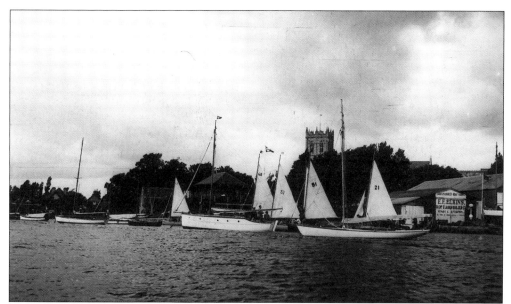

Sailing on the Quay, c. 1938. In the centre right is the famous and much loved *Ianthe*, once owned by Melvill Druitt, Commodore at the Sailing Club for many years and brother of Herbert. *Ianthe* is now over 100 years old and though her first recorded race was in 1895, she remains a familiar sight at the club's moorings. Elkins' boat yard sheds and sign, together with the riverside petrol pump, appear on the extreme right.

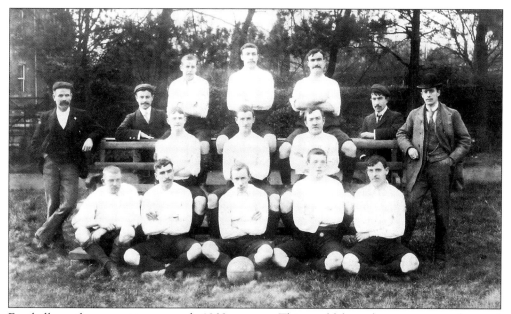

Football on the recreation ground, 1902 season.. This could have been any one of several Christchurch clubs around at the time, so great was the local support. In 1906 are listed the Christchurch Albions, Christchurch National, Christchurch Harriers and even a Gasworks team. In 1911 there was a Christchurch A, B, and C team. Matches on the 'rec' would occasionally attract 2,000 spectators. Rivalry between these and regional teams was intense and sometimes led to accusations in the local press of players being poached by rival teams.

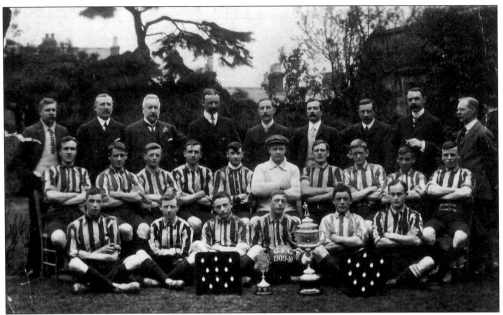

The famous 'Can't Whack 'Ems'. Christchurch Football Club earned one of its nicknames (the other was the 'Rag and Bone' team) from its celebrated exploits on the field. This club was reformed - one of that name was around in 1885 - after the Christchurch Wednesdays hung up their boots in 1909 and handed over their nets and posts to the new team. Above, they line up after the 1909 season, but it was in the 1911 season that their invincibility was demonstrated, when they won no less than five cups (see below). The only players identified so far are Alan Peden on extreme left, then on the extreme right of the same middle row, 'Rookie' Burton and Tom Jonas. Players named below are S. Butler, C. Bishop, W. Starmes (captain), F. Troke, L. Newman, F. Whiterow, S. Burton, C. House, Dunford, Newall, and Jonas.

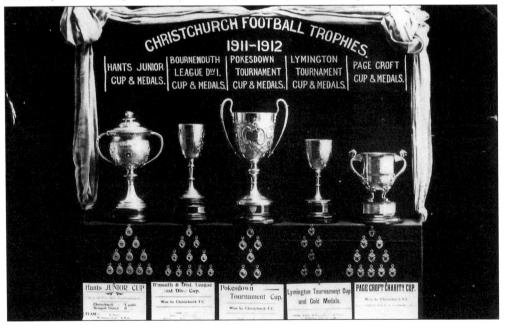

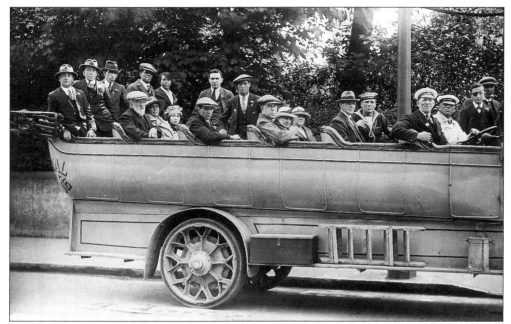

At the end of each season it was time to celebrate or commiserate according to the outcome. Shown here is the Christchurch Supporters' outing in a charabanc, destination unknown, at the close of the 1919/20 season. The party looks very neatly attired; all but two of the men have caps or other hats and jacket, tie and waistcoat, apart from one young rebel in naval attire. There are five women in the party, each one wearing a hat.

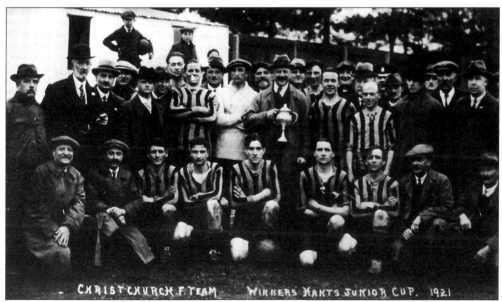

Christchurch Football Team, 1921. Their president, Dr A.H.B. Hartford, who lived in the beautiful Square House, holds the cup. Players identified from the picture are: Mr Cox, a shopkeeper for Windsor and Neate; Mr Tizard, the water bailiff; Jimmy Preston; William Preston; 'Rookie' and 'Soldier' Burton.

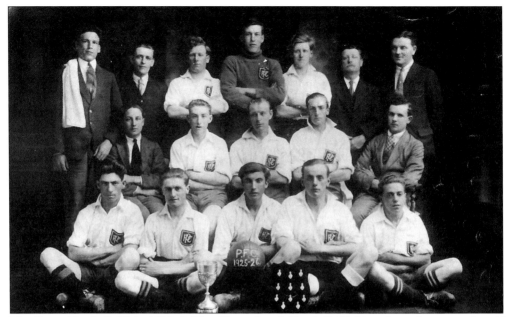

The Priory Football Club, 1925-6. The Christchurch Football Club confusingly renamed itself the Priory Football Club in the 1920s, but reverted to its former name in 1935. The talented Walter ('Wally') White is the captain in this picture. The club is still in existence and used to play on the town recreation ground. At this time the facilities there were absolutely basic, consisting of changing rooms converted from beach huts. In 1983 they moved to their present ground at Hurn Bridge.

Golf links, Highcliffe, at the other end of the sporting (and, possibly, social) spectrum. The golf course was provided by Major-General Edward Stuart Wortley of Highcliffe Castle, an enthusiastic sportsman, within the grounds of the Castle in 1913 and opened by Queen Victoria's daughter, Princess Helena of Schleswig-Holstein, and her daughter, Princess Victoria. It was extended from 9 to 18 holes fourteen years later. Since 1949 the club has been owned by the members.

The tennis courts opposite the King's Arms were laid out for the benefit of the guests. There is mention of a bowling green belonging to the hotel in Edwardian times, but whether this was where the courts are, or in other parts of the gardens (now car parks), is not clear. What is clear is that by 1925 the courts were gone and the green had opened. There were other courts in Barrack Road near the present police station from about this time.

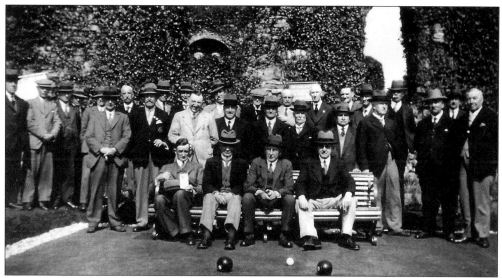

The bowling green and club, 1936. The relaid or new green was in use for the first time in August 1925 and over seventy years' later is as popular as ever. Lined up for the camera with the Constable's House behind them, the members include Mr W.A. Bolton, seated on the bench, right, who was the Bournemouth Singles Champion; the club captain, Mr H.J. Martin, next to him; Mr W. Tucker, the club's president next along, and the mayor, Councillor Douglas Galton, completing the seated group.

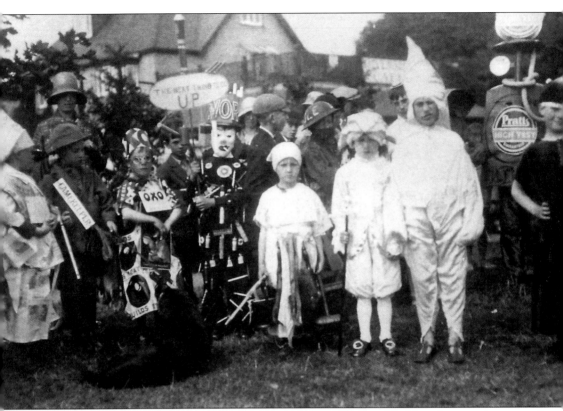

Carnival, 1928. This was the hugely popular Hospital Carnival held in August, the proceeds going to the voluntary Royal Victoria Hospital. Here on Quomps is a motley gathering of fancy dress merrymakers. Arthur Bennett is clothed from head to foot in newspapers and holds a card saying, 'Daily Mail for Insurance'. Little Alan Vick with his dog is disguised as a gamekeeper, holding an airgun purchased from Street's for 5s, the finishing flourish a 1s hat bought from Burnie's. The other known participant is John Kerley impersonating an Oxo advert (the card says, 'With Milk Served Hot'.) Pratt's High Test petrol pump surely merited first prize, with the Fireworks creation a close runner-up.

Six
People

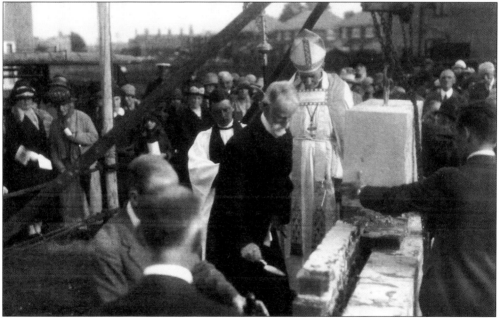

Laying the foundation stone for St George's church, 28 August 1927. Wielding the silver trowel is James Druitt junior, one of the benefactors in memory of his well-known father, James Druitt senior. With him are the Bishop of Southampton and Canon W.H. Gay. The Priory vestry clerk, Mr J.B. Hyde, donated the land and Commander Shrubb of Mudeford provided workmen to clear it. Named after the first priest of the old tin church it replaced, the Revd George Seymour, its origins were even earlier, as a Sunday school run in a cottage in Fitzmaurice Road.

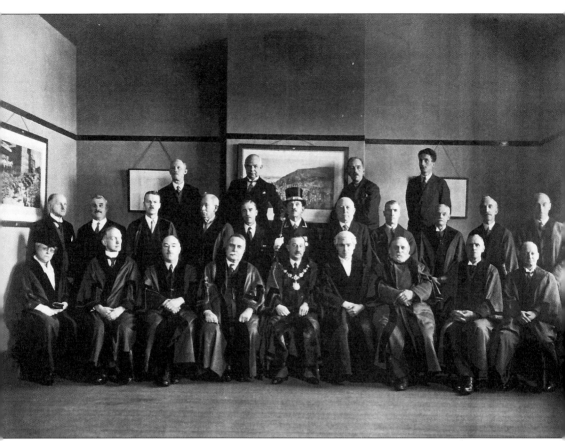

Town Council, March 1932. The stern-looking line up in front of the patriotic pictures comprises, back row: C. Crowther (Sanitary Inspector); H.J. Farmer (Borough Surveyor); Major Bellairs (of the Moorings, Mudeford); Mr Stainer. Middle: Mr Emerson; Mr Derham; Major Martin (the vet); Mr Gelsthorpe; E.E. Carter (Borough Treasurer and Manager of Lloyds Bank); H. Hewitt (Mace-bearer); J. Nutman (Rate Collector); A.E. Shave; E. Russell Oakley (local historian); W.G. Spickernell (Managing Director of Jenkins and Sons, master builders); J.C. Wyatt (Head of the Priory School). Front: Miss Mona Robinson (Head of Mudeford School); H.J. Martin; Norman Barnes (once organiser of the 'Can't Whack 'Ems'); Frank A. Lane (estate agent); John W. Tucker (Mayor); W.D. Platt (Town Clerk); Alderman D.A. Crockett (former workhouse master); H.R. Prichard (nurseryman).

The Mayor, Councillor John Tucker, 1932. He was a member of a prominent local family, his father being William Tucker, a previous councillor and mayor. His sons William and Bert were the last to run the high class family grocery business in the High Street established in 1798 by his great-grandfather, Ambrose. In his youth Mr Tucker used to tout for business around the local villages with a pony and trap. At the age of 87, in 1958, he was still working at the shop. Tuckers closed in 1960.

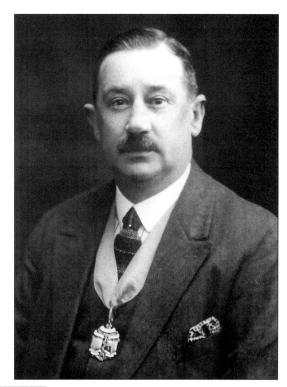

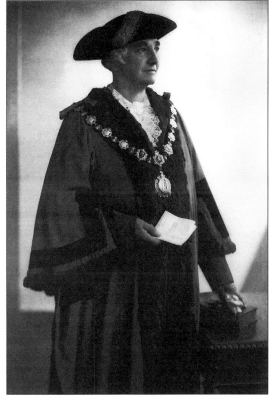

Councillor Mrs E.M. Wallis Power, mayor, 1952. Some idea of the interests and achievements of this remarkable lady, who left her native Ireland for Christchurch during the 1916 rebellion, is indicated by those attending her funeral in 1958. They included representatives from the British Legion, the police, the Red Cross, Christchurch Hospital, St John's Ambulance, the RSPCA and PDSA, the Guides, and local schools. Every year she threw open the gardens of her cliff top home, Culmore, in Highcliffe, for a fete in aid of the RSPCA. The house was sought as her memorial, but sufficient funds could not be raised.

73

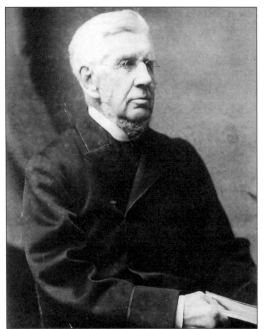

Dr James Kemp Welch, 1806-1887, came to Christchurch at the request of the Congregational Church minister, the formidable Revd Daniel Gunn. He served as Medical Officer for the Eastern Region and also had a practice with Dr Watmough of Quartleys. His imposing residence is now the National Westminster Bank in the High Street. The family were originally the Kemps of Poole and assumed the name of Welch from the maternal side by Royal Licence in 1795; his father was Martin Kemp Welch. Dr Kemp Welch was on the Board of Guardians for eleven years, being chairman for some time, for twenty years a lighting inspector in the town, a deacon at his church, and four times mayor - a very active gentleman. His brother, John, owned Sopley Park.

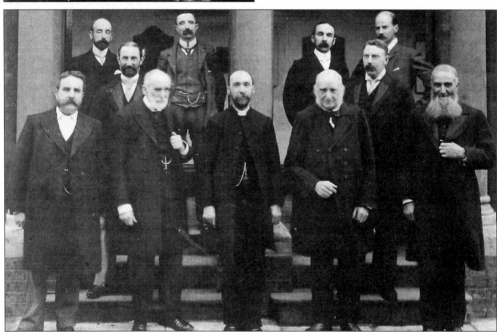

Minister and deacons for 1902 at the Congregational Church. Nonconformity was a powerful force in Victorian and Edwardian Christchurch (see page 23). The gentlemen above are, back row: Mr A. Skoyles; Mr R. Burnie (probably Robert Burnie, the owner of the shop of that name); Mr F. Froud (another High Street shopkeeper); Mr W.H. Pardy. Middle row: Mr W.H. Scott and Mr Howard Lane (grocer, Church Street). Front row: Mr Frank Lane (estate agent, brother of Howard and father of Donovan Lane); Mr John Green (at one time a chemist in the High Street); Revd J. Learmount; Mr Marshall and Mr George Marshall. Several of these gentlemen had served or would in the future serve, as mayors.

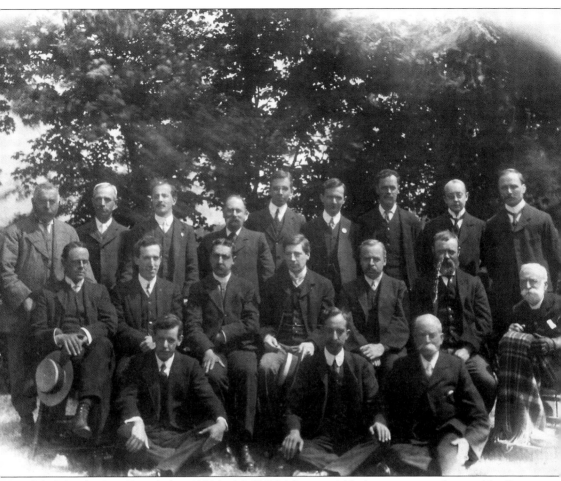

Adult School, 1914. Founded in 1909 by Mr H.W. Mooring Aldridge, amongst others, at No. 8 Millhams Street (since demolished) and thriving until some time after the Second World War, the Adult School promoted knowledge in all spheres and attracted the local intelligentsia as both speakers and members. Although this group is entirely male, there was a women's section as well. Back row: T. Jenkins, Mr Sheppard, -?-, H. Harding, Frank Donovan Lane, G. Longman, W. Lane, Herbert Druitt, H. Peaty. Middle row: F.E. Abbott, Mr Charnock, George Marshall, H.W.M. Aldridge (president), A.H. Owen, F. Clarke, A.H. Searle. Seated: R.T. Jones, W.G. Spickernell, Mr Webb.

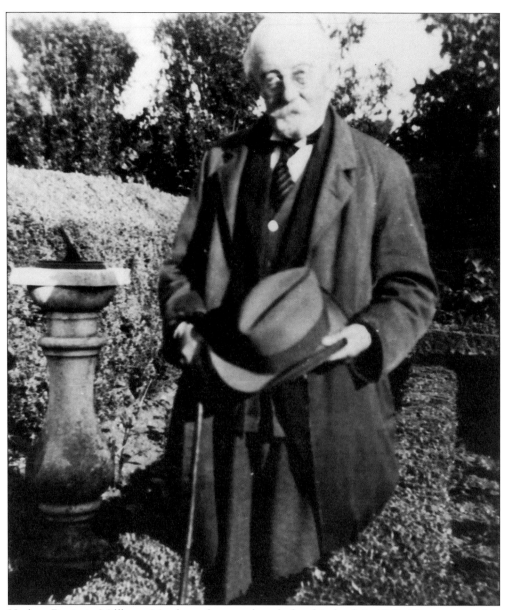

Herbert Druitt in Millhams Meade gardens not long before his death in 1943. The most notable figure ever produced by Christchurch, he was an exceptionally able and essentially compassionate man who championed many local causes, especially those connected with historical matters. His most lasting achievement was as an antiquarian collector and writer with a passionate determination to preserve and record every aspect of the town's past. As he said in one of his countless letters, 'No one has the well being of Christchurch more at heart than I have.' His legacy, through his sister Charlotte, is the gift of the museum and library. Ahead of his time and often regarded as a crank, he also displayed a deeply protective attitude towards all living things, seeming better able to empathise with his dog and stray cats than with his flawed fellow citizens. Mr Druitt stands beside a sundial with its own story to tell, for it was fashioned from a balustrade from the old London Bridge after it was dismantled in the Georgian period, and passed into the Aldridge family of Millhams Meade.

Seven
Events

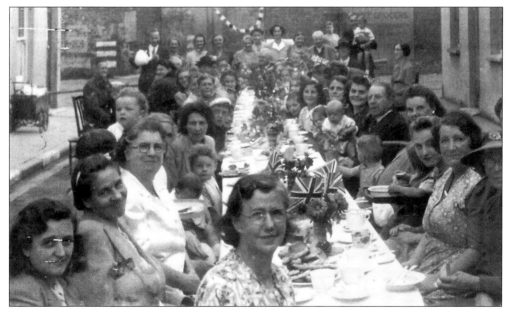

Millhams Street VJ Party, 1945. Residents sealed off their busy side street to accommodate tables and benches sufficient for 70 children. One of many such celebrations, it featured games and competitions and culminated in a grand bonfire and fireworks.

The century got off to a peaceful enough start with a visit to the Priory church from the future Edward VII. He was staying with his good friends the Cavendish-Bentincks (possible accompanying him here) at nearby Highcliffe Castle, which they were renting whilst Major Stuart Wortley was away in the Boer Wars. The party was met by the vicar, Revd T.H. Bush, plus the usual civic dignitaries, whilst people in the crowd pressed their faces against the Priory gates but were not permitted closer. The wall behind them is the boundary with the garden of rest.

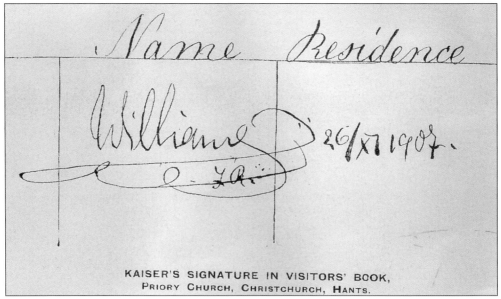

KAISER'S SIGNATURE IN VISITORS' BOOK,
PRIORY CHURCH, CHRISTCHURCH, HANTS.

The Kaiser's signature. Another august visitor at Highcliffe Castle who made the pilgrimage to the Priory was the Kaiser in 1907. He promised to replace the organ, which he deemed to be shabby, in the event of him becoming King of England. Fortunately he never had to keep that promise. It was rumoured that he was accompanied by a team of spies taking photographs of anything of strategic or cultural value. Presumably the organ was not included. He also visited Viscount Fitzharris, his godfather, at Hurn Court, and presented him with a gold cup.

78

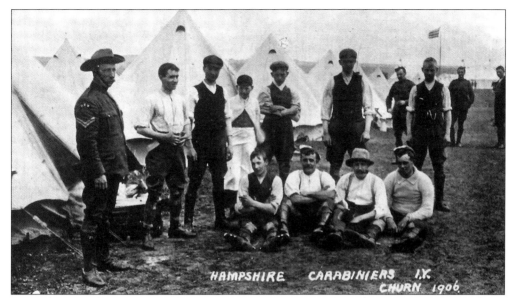

Hampshire Carabiniers Imperial Yeomanry at Hurn in 1906, formed in 1887 and absorbed into the Territorial Force in 1908. These valiant volunteers were required to undertake a minimum of six days in training camp and regular drills. The drills consisted of swordsmanship, rifle and carbine practice, plus reconnoitring and rough-riding for cavalry. A 170-strong contingent of Carabiniers departed from Christchurch Barracks in 1900 to serve in the Boer Wars.

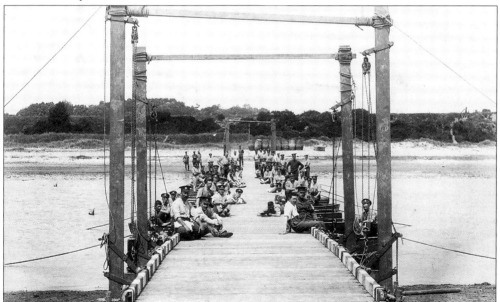

The Run at Mudeford in the late nineteenth century was more extensive than it is now, and an ideal training ground for the army. Even in Victorian times the RHA from the Barracks fired shells towards targets on rafts from the vicinity. Horses from the military camp at Hurn also practised swimming skills here. A few years later the Royal Engineers were perfecting their bridge-building skills across the Run and the men camped on the fields at Mudeford Farm ('Bure Camp'). This 1910 view is from the sandspit towards the beach. These practices continued until well after the First World War.

Memorial procession to the service at the Priory for King Edward VII, 1910. The Edwardian period had come to an end with his death, which was deeply felt. This municipal procession was some 180-strong and followed an earlier one comprising more than 400 people. Behind the throng an interesting view of the Square House and the Christchurch Brewery and its pedimented gateway has been captured incidentally. On that gateway was inscribed in gold lettering, 'Christchurch Brewery, established 1723. Strong and Co.'

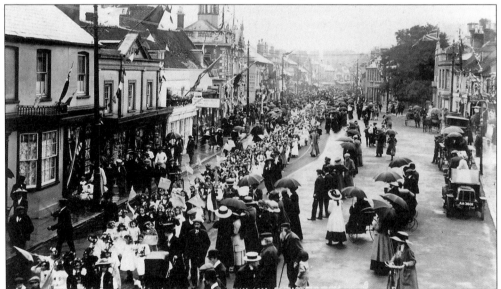

The subsequent coronation of George V and Queen Mary was celebrated in the town with extraordinary zeal. A committee of no less than 100 was created to organise it, divided into six sub-committees responsible for the procession, decorations, sports, grounds, tea and 'general': a huge programme of events culminating in the singing of the national anthem in the Square. Unfortunately, there was not a weather committee; as can be seen, the day itself was a washout.

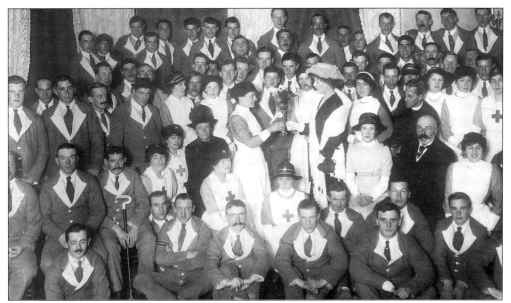

Opening a Red Cross ward at the workhouse, c. 1915. The role played by the VADs in requisitioned buildings at the workhouse was of enormous benefit to the trench casualties from the front. Men of many nationalities were shipped to Southampton, entrained to Christchurch station and then brought by volunteers to the hospital at Fairmile. Temporary structures were rapidly erected to deal with the flow. Here, Lady Malmesbury, the local Red Cross president, does the honours, surrounded by wounded soldiers dressed in the uniform blue suits and red ties issued to patients.

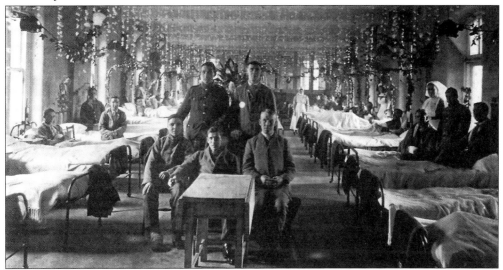

Kitchener Ward, Christmas 1916, at the Red Cross Hospital, having won the ward competition for best decorations with a cotton wool snowfall. The charity gradually took over other buildings at the workhouse. Starting with one 50-bed infirmary, at the end of the war it occupied two large infirmaries together with temporary structures housing 300 patients. The wounded soldiers regarded the VAD nurses as angels. On discharge, some went to recuperate at Hurn Court, which Lady Malmesbury had converted to an auxiliary hospital. Yet after the war was won, some soldiers were reduced to begging for food at private houses.

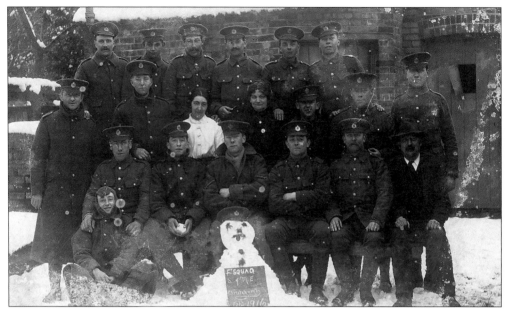

F Squad, 1916. The squad was from the School of Military Engineering based at Chatham, and are shown here - almost certainly at the Barracks - in February of that year, having found time to have some fun in a rare Christchurch snowfall. The importance of the Barracks in the contribution they made to the history of our town cannot be underestimated. One wonders how many of these happy faces survived the horrors of the trenches.

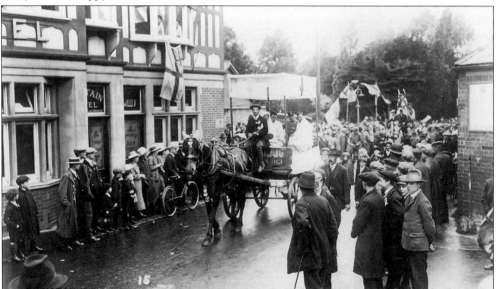

Peace celebrations, 1919. At the news of the cessation of hostilities in 1918, Herbert Druitt wrote: 'By 12 o'clock all the children with little flags - in afternoon the RE band and about 200 men paraded through the street. More flags hung out, the church flag put up in the evening and the bells rung... corner full of soldiers shouting... the [blackout] paint taken off the lamps in the streets in the evening, quite a brilliant effect compared with what we were used to.' As so often with Christchurch, heavy rain must have somewhat dampened the spirits during the formal celebrations the following July.

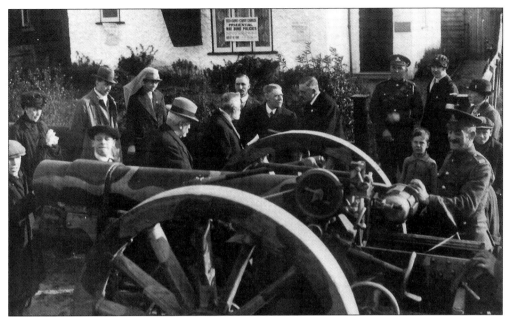

Trophy guns. Two captured German field guns were acquired on request from the War Office in 1919 and, after much delay, one was installed by the Quay approach road and the other by the Town Hall. The gun near the Quay had a plaque recording that it was captured by the 45th Battalion AIF 28 August 1918, presented by the mayor, L. Agate, 1921. When the threat of war once more loomed, these guns were seen as 'grim relics, unwanted horrors', and were therefore destroyed in 1938 as symbols of aggression.

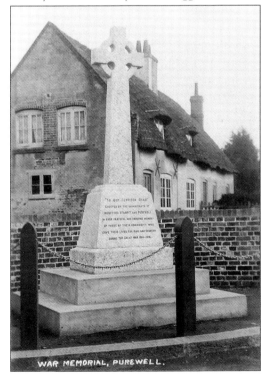

WAR MEMORIAL, PUREWELL.

War Memorial, Purewell Cross, in its original position. On the plinth is the inscription: 'Erected by the Inhabitants of Mudeford, Stanpit and Purewell', and on the side: 'When you go home, tell them of us and say for your tomorrow we gave our today.' The memorial was unveiled in November 1920. In the background is Shirvell's 'Purewell Hygienic Bakery', established here as long ago as 1811 by John Shirvell. They made 'tops and bottoms', a sort of rusk to be soaked in milk, and sold Mazawattee tea, homemade lemonade, soda water and ginger beer.

Proclamation of the death of George V and the accession of Edward VIII, 1936. The crowd in the High Street is attentively listening to the announcement of the mayor from the Town Hall balcony. The King, of course, was not crowned as a few months later he abdicated. The late-eighteenth-century buildings behind the crowd, one of them the office of Herbert Wooff, auctioneer and valuer, were pulled down two years later and replaced by three-storey shops.

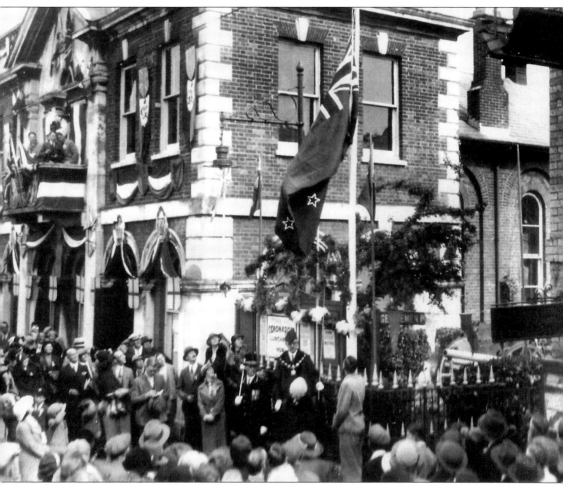

Coronation of George VI, 12 May 1937. Following the abdication debacle, civic representatives once more emerged to co-ordinate festivities. The Town Band was especially formed, and the procession from the Quay reached the Town Hall as arranged, where the New Zealand flag was hoisted. All then proceeded to the recreation ground for an open air service. After this, the meticulously prepared programme had to be abandoned as a thunderstorm erupted and the deluge rapidly dispersed the participants. A memorial fund was used to finance the children's playground on the 'rec', the first in the town. Note the German gun.

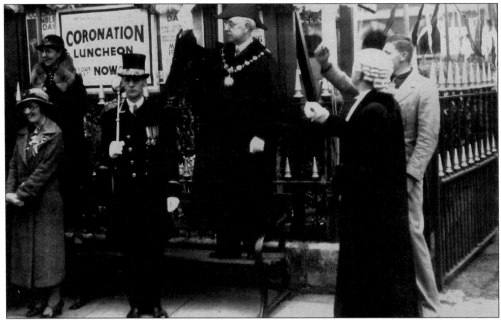

Close-up of the coronation, capturing the encircling railings around the Town Hall, so soon to be destroyed in the succeeding war. Railings of artistic or historic merit were excluded, but strangely these were not deemed to fit that category, in an age when such decorations were considered vulgar Victorian adornments. Those protected included those belonging to Church Hatch, Gundimore Gate and Highcliffe Castle. In vain did Herbert Druitt thunder: 'We should think of the future as well as the present.'

Coronation decorations. All around the town enthusiastic and patriotic householders and shopkeepers put up bunting and flags in celebration. Here we see the Bargates newsagent, Stedman's, playing its part. Outside the newspaper headlines are not unanimous in giving the occasion star billing. The *News of the World* prefers to lead with: 'Hollywood Stars Ready to Strike'.

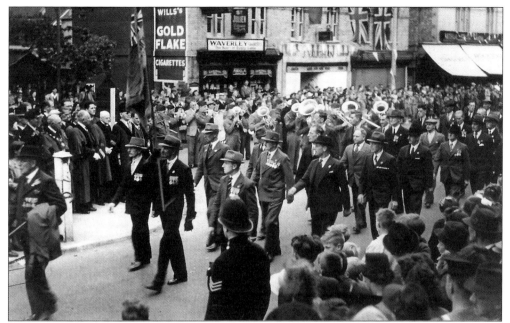

Victory parade, 1945. Another hard war had ended. On 13 May of that year, Thanksgiving Sunday, the salute was taken outside the Town Hall by Lt Comm D. Scholes of the Fleet Air Arm. The parade of servicemen that followed was headed by the Home Guard Band and included the WRNS, WAAF, the Loyal Observer Corps, British Legion, fire and police services, the Red Cross, St John's, army cadets, scouts and guides.

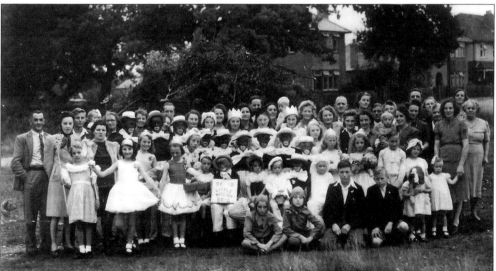

VE and VJ Day parties brought together communities all over the borough and villages. This is the Albion Road, Fairmile, VJ party. Poor weather meant that the tea for the forty-four children had to be eaten indoors, but a gramophone provided a happy atmosphere. Each child was given a slab of precious chocolate, the adults having forfeited a month's sweet coupons to provide them. Here the children, in fancy dress, line up in front of a huge bonfire. At Albion Road's VE Day party a few months' earlier, the guests had had the satisfaction of burning an effigy of Hitler.

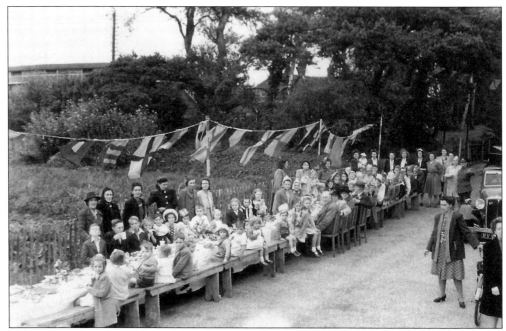

Arthur Road and Manor Road joined forces to provide a VJ Day feast for sixty children. Entertainment was provided by a Punch and Judy show and the evening concluded with the spectacle of two guys being burnt on a huge bonfire.

Portfield Close VJ Party. Mrs Galton, the Mayoress, cuts the Victory Cake as the excited children await their portion and their parents and neighbours look on. One hundred and fifty children attended this party, so many surrounding streets must have participated. The excitement continued into the evening with sports and fancy dress events and a bonfire.

Banana queue, Castle Street, 1946. The last bananas Christchurch people tasted may well have been those ripened in the former cornfactor's warehouse in Woolworth's yard in 1939. In February 1946, fresh supplies at last arrived. A week later there was a so-called 'banana riot'; five hundred customers lined the pavement to collect their allocation of 1 lb per person from the Priory Fruit Stores. Other queues, in which women were reported as having fainted, would form when news arrived of other almost forgotten fruits such as strawberries or oranges.

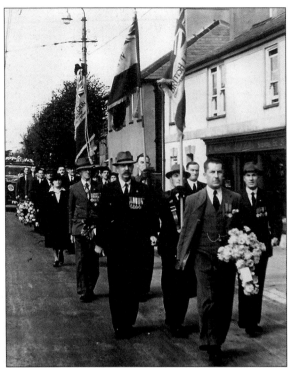

Funeral of Major T. Wombell MBE, September 1946. The year after the Christchurch Royal British Legion purchased the old Rialto cinema in Bargates for their new headquarters, their president's funeral cortege wends its way to the Priory. Major Wombell started the local Home Guard - the 'Broomstick Army' - with Captain Arthur Hornby (leading the procession). The first standard is the branch standard, now laid up in the Priory; the second probably that of Highcliffe; the third is that of the Christchurch Women's section, also now in the Priory.

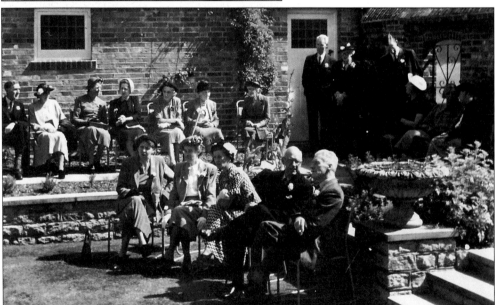

The Red House Museum, 1952. In the foreground is Dr Norman Deane; next to him, Bill Morgan and his wife, master and matron of the workhouse from 1921-46. Mr Morgan was Commodore of the Sailing Club for many years. Herbert Druitt inherited the Red House, the original workhouse, from his mother and opened it as a private museum for a few years up to around 1922. His ambition for a museum for the town, for which he collected extensively, was only realised in 1951, eight years after his death. The guests are relaxing in what was once the boys' yard, surrounded by a high rear wall.

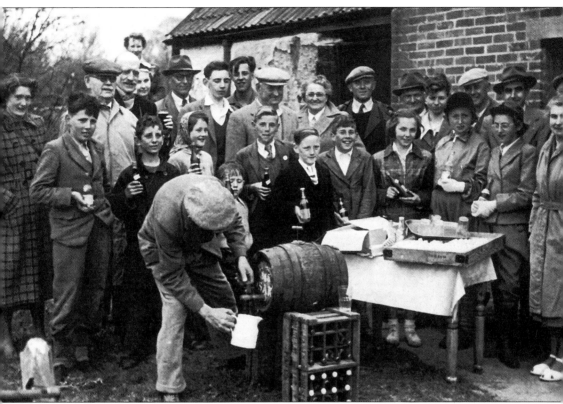

Cowards Marsh. The agricultural character of the town, now largely lost to development, is captured in this early 1950s picture of the annual May breach of the marsh, revived after lapsing in the First World War. To mark the opening of this ancient common land, which is documented back to at least 1718, for the grazing of the commoners' animals, herdsman Arthur Starks opens a barrel of beer and buns and cakes are given to the children. The Marsh House behind them was built in about 1750 for the herdsman and restored in the 1980s. T.H. McArdle stands third from left.

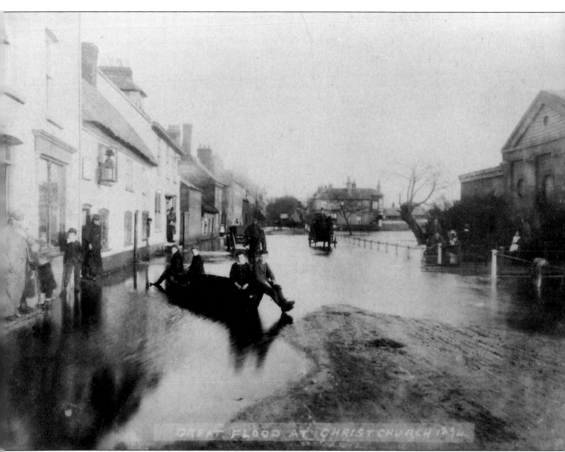

Floods in 'Rotten Row', Bridge Street, 1894. Apart from the intrinsic interest of the inundation, this picture shows several buildings which played a major role in the story of the town. The notorious Crispin Inn (thatched, plus attached house), since demolished, displays a hanging sign which indicates that it was a 'bush house', i.e. one allowed to brew extra beer supplies on days of the great fairs. It became renowned for its clientele of tramps, hawkers and gypsies. The landlords for many years were members of the Troke family. Two small girls near the cart stand by the fusee chain workshop of Jenkins and Son, the tools of which went to the Basingstoke Museum after the workshop burnt down in 1951. In the central distance is Keffen's house next to the Star Inn, demolished 1975. The gasworks were constructed as long ago as the early 1850s, replacing the oil lamps with gas lamps in the streets. The frontage has since been altered.

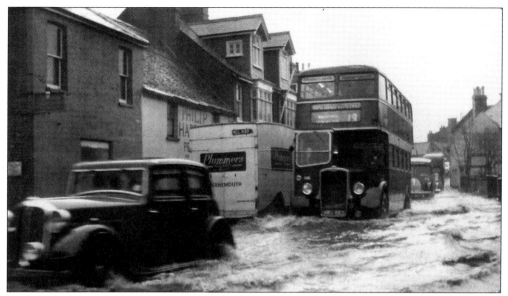

Bridge Street, 1950s. This view probably shows the very serious flooding of 1954 that put the road outside Mulleys china shop (behind the van) under 2 ft of water and other areas under 4 ft. Cups and saucers floated crazily around in the rear store. Dozens of cars were stranded in the street and bus drivers were instructed to proceed extremely slowly here to avoid washing even deeper water into the houses. At Mudeford sandspit, 40 ft of the beach was washed away. Theories for the cause varied, but old maps show an extensive system of drainage channels which have gradually been built on or filled in.

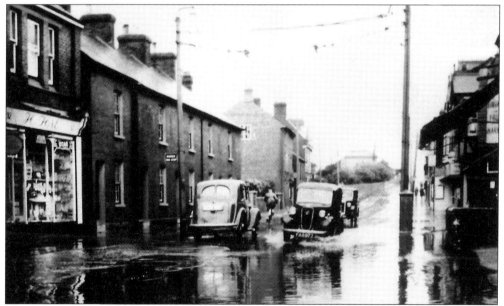

Bargates floods, 1950s - a most unusual occurrence in this road. On the railway bridge the signal box is visible; it is, of course, no longer there. On the left is a garden wall, behind which the house shown on the back cover was used by Taylor and Son, builders, as an office. This was redeveloped in the early 1980s as Gilbert Court. The trolley bus overhead wires remained until the end of that service in 1969.

Snowfall, 25 April 1908. This must have been very fleeting, since it failed to create much of a stir in the contemporary news reports, only meriting a brief reference to 'wintry weather'. There had been a very severe winter in 1895, when Christchurch people took to the fields which had become unofficial skating rinks.

Eight
Mudeford

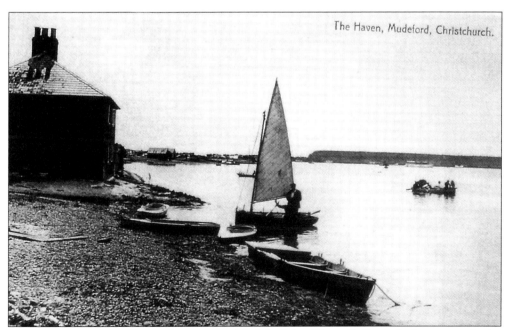

Inter-war view of the Haven Cottages on Mudeford (or 'Haven') Quay, looking towards the sandspit.

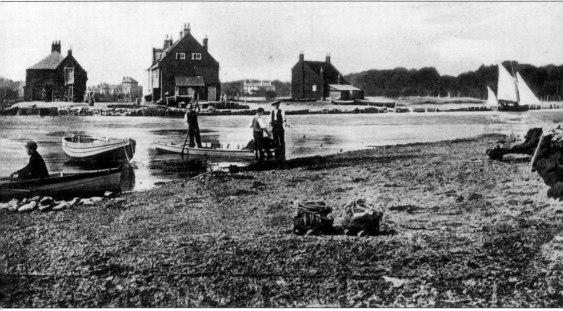

'Haven' Quay, viewed from the sandspit, was at one time a remote and lawless appendage to Christchurch, not even part of the borough until 1912. From left to right: Preventive Station for the Revenue Men; Haven House, later known as the Dutch Cottages; and the Haven House Inn. The cottages are the oldest, being at least seventeenth century, the station cottages seem to be early nineteenth century and the inn a little later. It is well known that the extensive smuggling trade centred on this strange group, but less commonly appreciated that the Quay was important for such exports as beer, rushes and grain. It is one of history's ironies that spirits came in illicitly and beer went out quite lawfully. Even as late as 1882, the materials used to construct the first (wooden) Tuckton Bridge were delivered here.

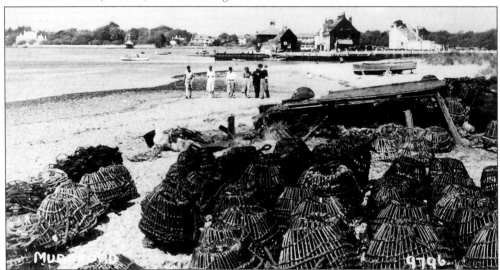

A later view, c. 1953. Traditionally, the lobster pots were made by the fishermen from young willow shoots, afterwards coated with tar obtained from the gasworks; for a while between the wars, some were also made in Christchurch by Hill's in Castle Street (the so-called old Court House). Modern pots are made with plastic-coated steel.

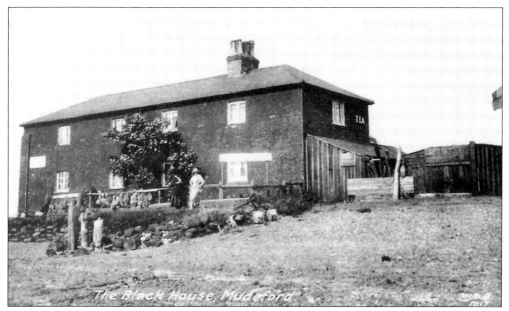

The Black House, probably around 1912, at which time it was a tea house. Often thought to be as ancient as the Dutch Cottages on the other side of the Run, the Black House was actually not built until about 1848, seemingly for the manager of the Hengistbury Head [ironstone] Mining Company. Prior to this the site was used for a few years for the construction of sizeable ships. Currently, it presents a forlorn and abandoned sight.

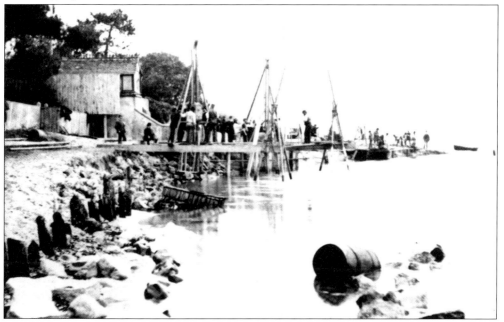

Gundimore sea defences in the early twentieth century. The fury of the sea was often vented on the Mudeford coastline and on many occasions sea walls were constructed to protect the 'marine residences' which bore the brunt of the onslaught. Such work provided a winter income for local fishermen. The modern promenade and concrete walls are much further inland than the original boundary walls.

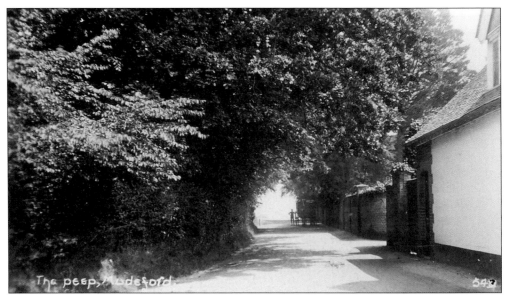

The Peep. No longer referred to by this charming name, which is nevertheless quite appropriate, the lane is the approach to the Avon Beach. Behind the hedge was Capesthorne, initially a private house, then a country club before becoming a Red Cross home for recuperating children, before being redeveloped in the 1980s. Opposite is the wall of the Anchorage, built in about 1870 and originally called Elmhurst. A notable occupant in the Victorian years was Lord Bury who, with Charles Pride, earned an RHS Silver Medal in 1868 for the rescue of a fisherman from a capsized boat.

The Anchorage interior. When Lord Bury sold the house in 1880, the impressive terraced lawns with an Italian garden and shrubbery walks, extending to two acres, went as far as the beach where 'good anchorage' could be found. Around the lawn's edge flowed a pretty stream. Stabling, a coach house, a coachman's cottage, summer houses and a peach house were mentioned in the sale particulars. After a succession of wealthy owners it was sold by Lt Col Giles Daubeny DSO in 1929 for use as a convalescent home for retired teachers.

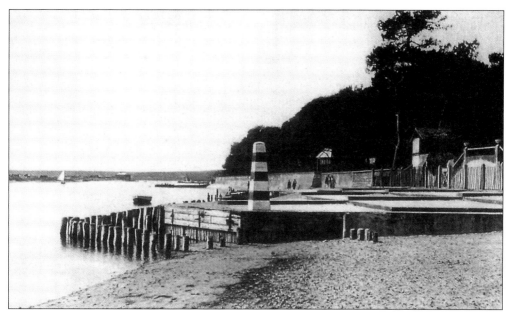

The sea wall in the 1930s. The object resembling an obelisk is a navigation aid known as a day mark, a function now performed by electric light devices. Avon Beach had been purchased in the early '30s by George Derham from Alfred Barnes, who in turn had bought it from the Highcliffe Castle estate. Because of serious erosion during and after the last war, the beach was bought by the Borough Council under a lease-back arrangement. The steps and rails into Gundimore's gardens appears on the right - this is probably the Gundimore Gate mentioned on page 86.

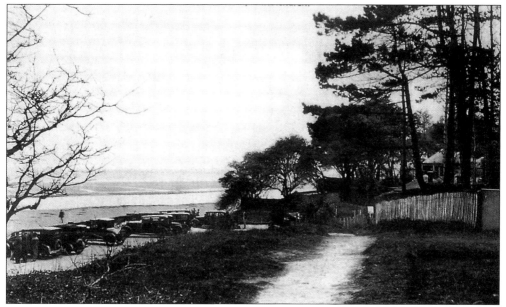

Another view from the same 1930s series shows the beginnings of the car park which has since been constructed, where the visitors of yesteryear have left their identical-looking vehicles. A line of chestnut paling is just visible in front of them. Despite Mudeford having been a resort in a quiet fashion for over a century, the scene remains very natural in appearance.

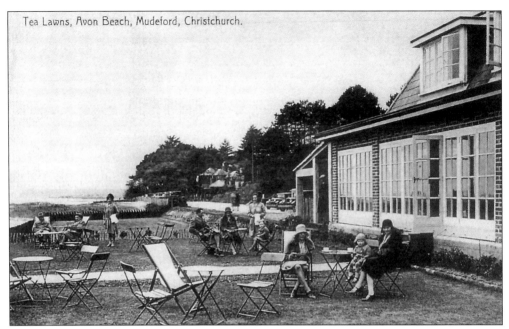

Tea Lawns, Avon Beach, Mudeford, Christchurch.

Avon Beach Cafe, 1930s. The photograph captures the elegant and unhurried character of an outing to the seaside over half a century ago. The war that followed damaged the beach severely, both by the unrestrained assaults from the sea and the removal of the sand for sandbags. In 1950 the sedate lawn was gone for ever, washed away by a renewed onslaught from the elements. It was replaced by more resilient substance - a concrete balcony.

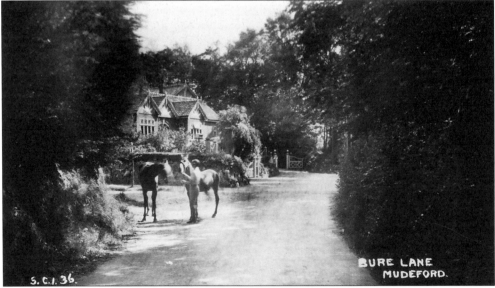

BURE LANE
MUDEFORD.

S. C. 1. 36.

Bure Lane in the 1930s. Once a shady farm track leading to Bure Homage, the 'improvement' meted out to this idyllic country lane became a local *cause celebre*. In 1938 it was deemed necessary to widen - and realign - it from 12 ft to 40 ft, with the consequent destruction of the high daisy and honeysuckle adorned bank adjacent to Bure Brook and all the grand old trees. The loss of such an ancient and charming piece of 'old England' was immensely regretted by many. The house, the Gables, is still there, at the corner of what is now Friars Road.

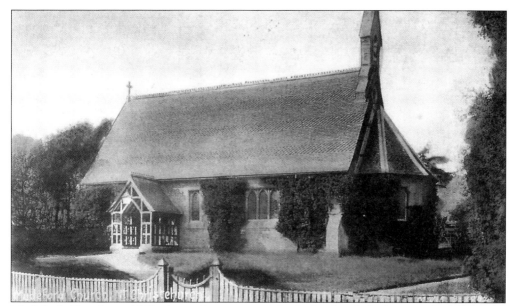

Mudeford Church, *c.* 1900. An early picture of the little church built around 1869 by the 'squire', Mr Mortimer Ricardo of Bure Homage, as a chapel of ease for the local fishermen. For a short time it was also the village school, the small bell being rung for the children rather than the worshippers. In the early days the church used to be decorated with nets and lobster pots; the unique 'blessing of the waters' carries on this traditional connection with the harvest from the sea. It remained undedicated until 1931 (as All Saints).

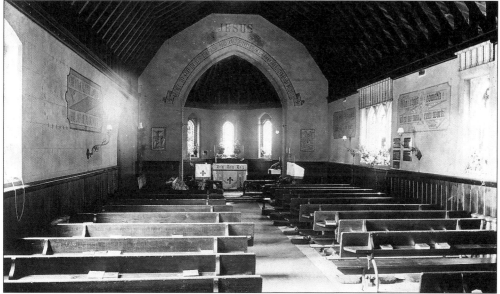

Inside the church, *c.* 1910. Many changes have taken place since then. The Gothic lettering above the chancel arch has been overpainted (it quoted St Luke C.1 v.14); all the solid wooden panelling has been removed; the inscriptions on the walls are gone; the pews replaced with more substantial furniture; and the windows fitted with stained glass, the central one being a tribute from a mother in gratitude for her serving son having survived the First World War. Note the glow from the gas lamps and the blinds above the windows.

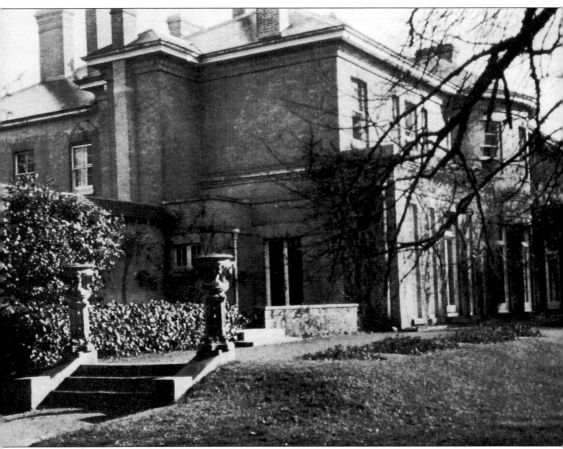

Sandhills was a beautiful late-eighteenth-century mansion built for George Rose, the sitting MP for Christchurch, who died here in 1818. Note the elegant dentilling under the eaves and around the chimney stacks. Captain and Mrs Wiggins came to live here in 1895. The Captain died soon after, but Mrs Wiggins went on to earn great respect for her enthusiastic and valuable support for many charities and societies. In 1911 an extensive fire seriously damaged the first floor and was only extinguished with the help of three fire teams using water from the Bure Brook running through the grounds. During the First World War the selfless Mrs Wiggins, who had four serving sons of her own, utilised the property as a convalescent hospital for wounded soldiers. In the Second World War she once again contributed by permitting the front boundary wall facing out to sea to be used for gun emplacements. The elegant garden seen here is now devoid of the ornamental stone features and tile-topped garden wall, departed like the gentry. Today, painted cream, the mansion co-exists with row upon row of static holiday caravans.

Nine
Highcliffe and Walkford

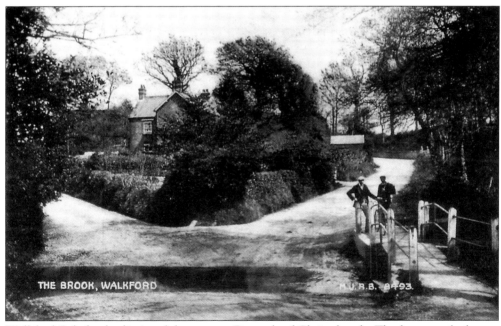

Walkford Splash, the limits of the present Borough of Christchurch. The house tucked away behind the trees is called Glen Cottage. This beauty spot is bypassed now by a modern road and the little wooden bridge has all but disappeared.

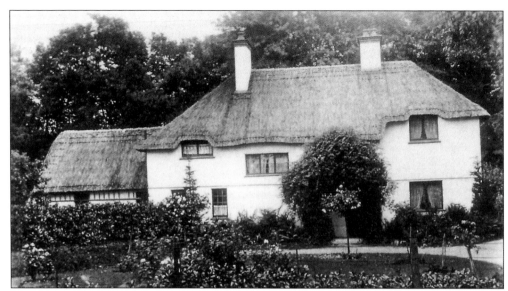

The Hoy, c. 1925. An inn for many years until closed down in about 1869 by the disapproving owner, Louisa, Lady Waterford, it is named after the type of boats which plied between the coast and the Isle of Wight, and hence its reputation as a smugglers' haunt. Its history in both occupations goes back a considerable way. When the Hon Col Stuart Wortley resolved to demolish it in 1906, it was reported that the Excise authorities could prove its existence as a spirits house back to the sixteenth century. Happily, it is with us still, and lovingly maintained as a private house.

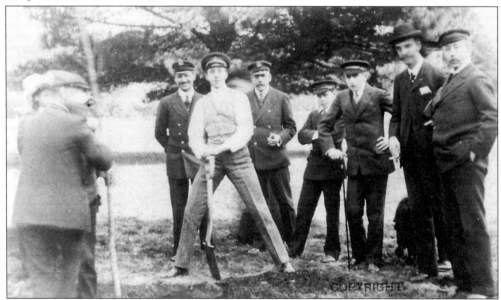

The Kaiser was only one of many eminent visitors to Highcliffe Castle; it became customary for them to mark the occasion by planting a tree beside the main drive. In 1906 the young Spanish king, Alfonso XIII, who had met the Hon Stuart Wortley whilst the latter was the naval attache in Madrid, paid him a visit. Here he is planting, appropriately, a Spanish chestnut in the lawn at the front of the house. The Colonel, as he was then, stands second from right. Strangely, the tree died just before King Alfonso abdicated.

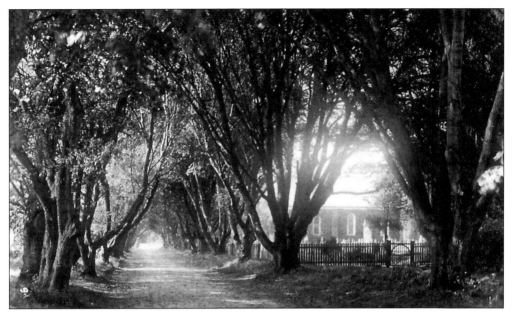

The Ilex Avenue. Lord Stuart de Rothesay not only rebuilt the Castle, but provided the village with the site and some of the expense of erecting St Mark's church, glimpsed on the right. The graceful avenue of so-called 'ninepenny trees' alongside was another of his gifts to the villagers, but disease has played havoc in recent years with the old holm oaks. The avenue is viewed here from its junction with the Lymington Road, just in front of the present position of the lych gate.

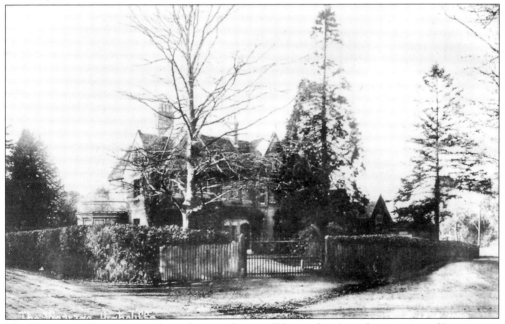

The Vicarage. The gateway where this stood can still be made out at the junction of Lymington Road and Hinton Wood Avenue, opposite the Hinton Oak Inn, although the building itself was demolished in 1966, just less than a century after having been built following the formation of the separate ecclesiastical parish of Highcliffe. The redeveloped site is now called Abbot's Close.

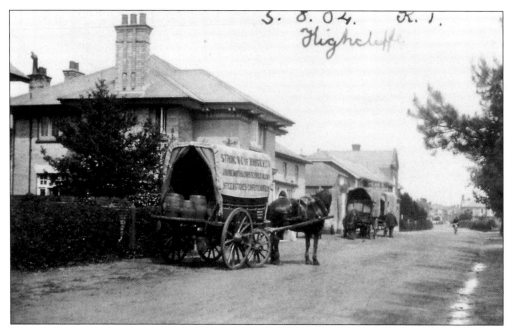

The Globe public house, marked '5 08 04'. Just two brewers' drays and a bicycle disturb the peace of the unsurfaced main Lymington Road through the village. The nearer dray has the words 'Strong and Co, Romsey. Office and Stores Christchurch', so would have come from the brewery buildings next to the Square House (see page 80). These buildings have little changed, apart from an office block visible behind the Globe's stables in the centre.

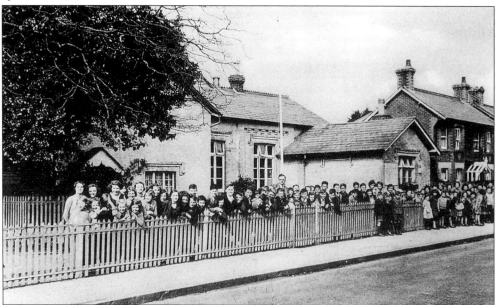

St Mark's School, undated, but probably in the 1930s. Opened as a National School in 1844, well before education was compulsory, it had previously functioned briefly as the Newtown Mission Church and a lecture room, and continued in a dual educational and social role. The first teacher, a Miss Belbin, was said to be the daughter of a respectable Christchurch bricklayer. A schoolhouse was added in 1856.

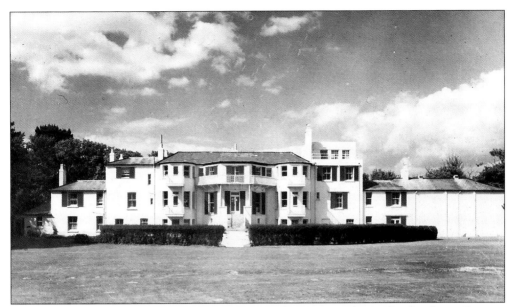

Beacon Lodge, c. 1950. Pictured here in its final role as a guest house for the Co-op Society, Beacon Lodge was unfortunately damaged by fire soon after. Part of the Castle estate, the early-nineteenth-century house on the cliff top had several unusual occupants. Grantley Berkeley, for instance, defied the orders of Sir George Rose to use the bathing machines on the beach, instead cutting a set of steps down and issuing tents to his guests. Baron Nugent lived there in the early twentieth century and later Major Cadbury, who created the popular cricket weeks. Nothing now remains of the house.

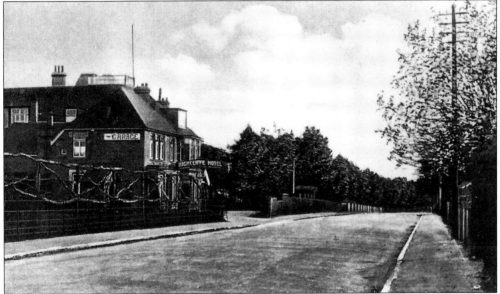

Highcliffe Hotel, Waterford Road, which began life as the Villa Mathilde before becoming a hotel in 1927. It was on the market in 1939 with the description: 'The most modern fully-licensed hotel in the district. Spacious lounges, hot and cold in every room, central heating... tennis courts in grounds'. The site is now occupied by two-storey terraced houses called The Lawns.

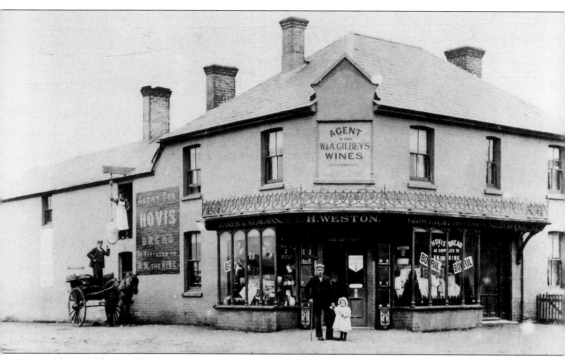

Above: Henry Weston's 'grocer and provisions merchant, baker and mealman', the date indicated by the signs for Hovis: 'Supplier to HM the King', suggesting an Edwardian rather than Victorian photograph. Note the sack hoist in use. Below: as Misselbrook and Weston in about 1935. The frontage has been extended and altered, the pretty ironwork removed and the famous landmark clock tower commemorating the coronation of King George V in 1911 added, the cost of which was raised by local inhabitants. The shop today has lost almost all its appealing features, including the clock tower. In its place is a plain white arched bracket of no aesthetic appeal protruding from an edifice entirely clad in white weatherboarding.

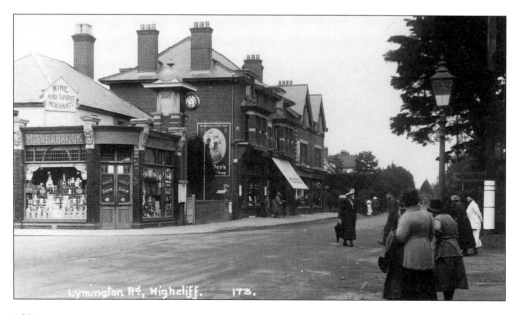

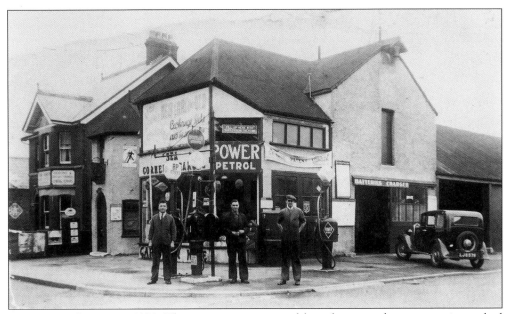

Sea Corner Garage, *c.* 1930. The site is now occupied by a large, modern garage, in marked contrast to the small enterprise pictured here. Around this time it was owned by the Netherclift brothers. Its facilities seem modest now: two petrol pumps dispensing Power Petrol or its rival, Shell; another pump has a BP Ethyl sign overhead. The building itself, with its rudimentary tin roof, seems to predate the car era, as what may have once been a sack hoist is visible on the gable end.

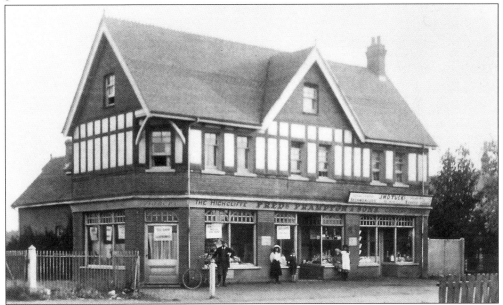

Frederick Frampton's Highcliffe Grocery Stores, on the Lymington road at Sea Corner, *c.* 1905. A bakery occupies the left hand corner, in use today as a small restaurant; on the other side J.W.D. Tuck's sign advertises his ironmongery business. The appearance of this building today is largely similar but the symmetry has been lost by an extension, although built to match the original exactly. None of the original shop front survives.

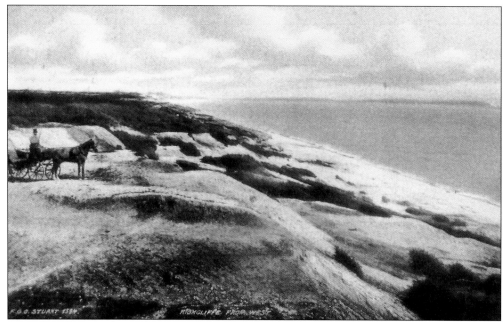

Pony and trap on the cliffs. This view gives us an idea of the beautiful natural state of the cliffs near Chewton Bunny as they then were, with no sign whatsoever of human interference. This was partly owing to its ownership by Major-General Stuart Wortley as part of the Highcliffe Castle estate until he sold it for £8,500 in 1925, after which it was administered by the parish council.

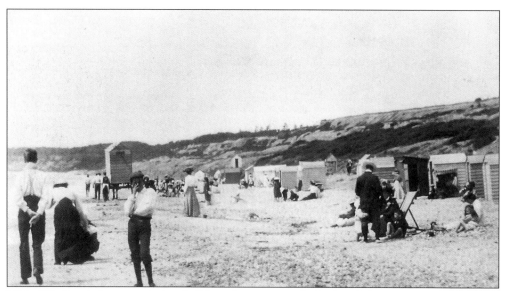

Highcliffe Beach from an obviously Edwardian view with the beach huts scattered about and another strapped to a cart being trundled towards its destination. Despite what appears to be a fine, warm day, the visitors are obliged to preserve their modesty no matter with what discomfort.

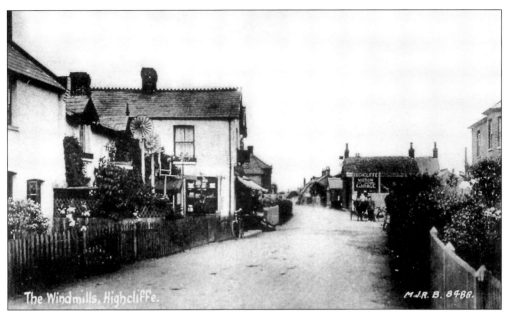

The Windmills. Above: Novelty Cottage was home to James Frampton, a retired builder with a fascination for these devices which he made and sold in aid of the voluntary Royal Victoria Hospital at Boscombe. Since he died in 1914 at the grand old age of 89, the picture must predate this, perhaps about 1910. James Frampton had sixteen children, many of whom left their mark on the hamlet that was to become Highcliffe village. Little in the picture remains today, Novelty Cottage assuming an altogether more sober appearance as the Portman Building Society. The cottage on its left also remains, unaltered apart from the replacement of the front garden with a pavement. Below: looking at the same section of the village from the other direction, i.e. towards Christchurch. The chimney on the right is a useful indicator marking the present Bucehayes Close. All the buildings on the left have gone and all those on the right are now shops.

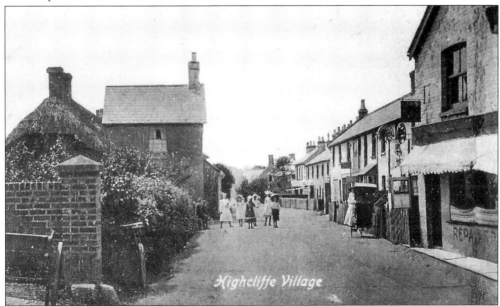

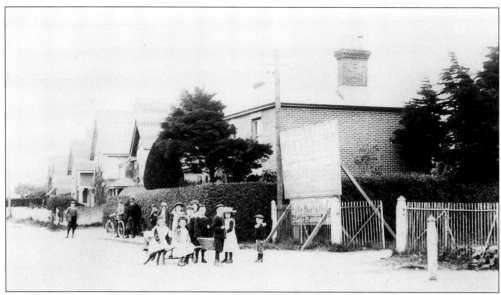

Sea Corner, 1904. This too is now virtually unrecognisable. Of the four gabled houses, only one remains - one half a piano shop, the other an undertaker's. All the rest have been replaced by modern shop and office blocks. The sign advertises the sale of plots on the Highcliffe Estate. Several such sales were held, from which such new roads as Stuart Road, Waterford Road and Wortley Road were laid out and lined with houses.

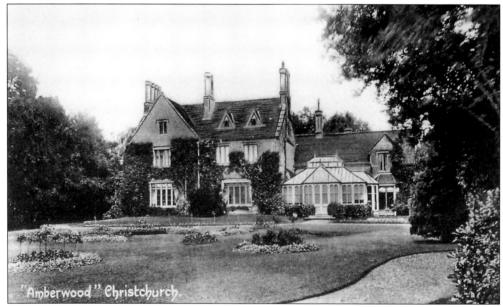

The hamlet of Walkford for most of the nineteenth century consisted chiefly of a brickyard, Cranemoor chapel, a few cottages and Amberwood, shown here. The sumptuously built half-timbered house of that name today does not resemble the original depicted here, as that burnt down in a disastrous fire in 1935 and was afterwards rebuilt. Amberwood in the last century was the home of a Mrs Mary Braddyll, a generous contributor to local charities and one who firmly stuck to her horse-drawn carriage method of travel and was never persuaded to update this mode of transport. She died in 1929.

Ten

Burton, Winkton
and Hinton

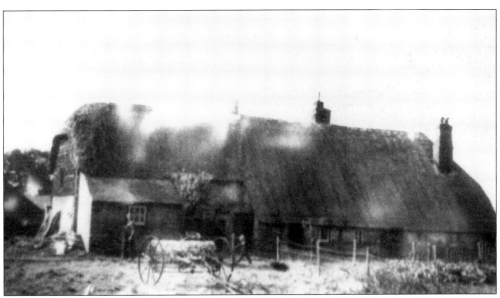

Dairy House Farm, Winkton Common, was last farmed by the Bolton family. An ancient building which appears on a late-eighteenth century map, it was sold for land development in the 1960s.

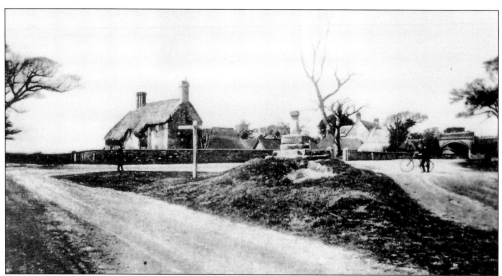

Staple Cross. There is evidence this was a fourteenth-century town market cross re-sited and converted to a plague stone in the seventeenth century. The coins were dipped in vinegar, thought to disinfect them, in the bowl structure on top. Note the mound on which it stood before the bypass was built and the upper part, which was demolished by an American tank in the 1940s. It stands at the junction of Ambury Lane in the foreground, Hawthorn Lane on the right, and Salisbury Road beyond. The Staple Cross Farm dairyman's cottage beyond is of particular interest, having timber framing on the rear elevation, suggesting a medieval origin, and a massive Tudor chimney. It is now encased in concrete and the roof tiled. Its outlook is now onto the bypass.

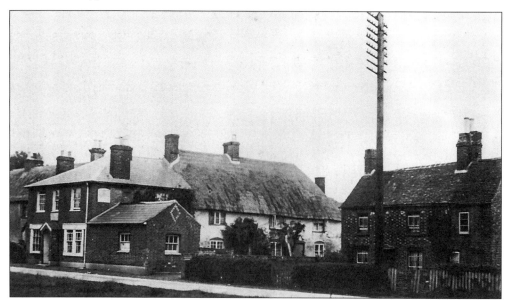

Burton Green House and attached bakehouse, c. 1920s. Most striking by its absence today is the row of three thatched cottages behind this former shop. The brick cottages alongside comprised two small homes and the one on the right was used as a farm store and office for Mr E. Lander, builder. This row has been converted to one single house (Pine Tree Cottage), the windows enlarged and the walls whitewashed.

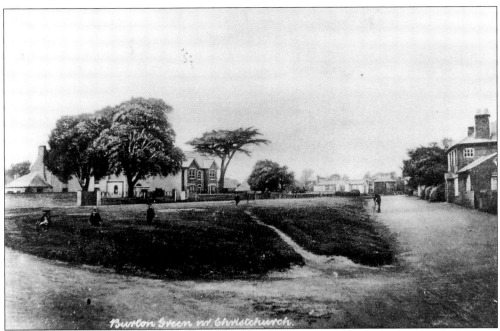

Two photographs of Burton Green. The one above looks north towards the school with the Congregational Chapel on the left and dates from about 1900. The large tree in front was felled just after the last war. The Victorian house is Burton Grange, now a doctors' surgery. The muddy track on the right is the Salisbury Road. The picture below looks towards the south and dates from about 1918. The cart was a baker's delivery roundsman from Quinton's and the group of children is standing outside the village school, which was a chapel of ease before St Luke's was built.

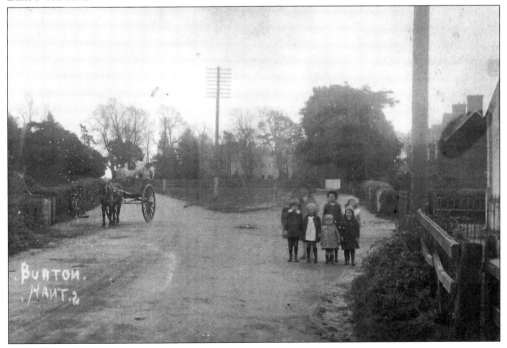

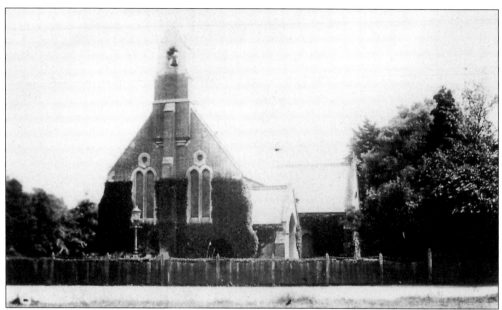

St Luke's Church, *c.* 1920s. Long before this church was built in 1874, there is said to have been an earlier church in the village at the Triangle, dedicated to St Martin, the font of which was rescued from a garden nearby and installed in St Luke's. Designed by a Christchurch-born man, the famous architect, Benjamin Ferrey, who was a pupil of Pugin, the church was built by Joseph Lander for the sum of £3,500, which was raised entirely by voluntary subscription. Mr Lander, who also built Mudeford School, was the churchwarden for almost forty years.

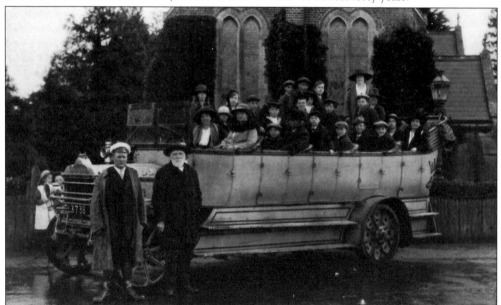

Choir outing, 1920. Once more, that favourite mode of transport, the charabanc, was used on the occasion of the annual outing, which here waits for the photographer before journeying all the way to Southampton. One of the young merrymakers aboard remembers the treat as a most exciting adventure, Southampton being the ends of the earth as far as she was concerned! Standing on the right is Revd Johnson.

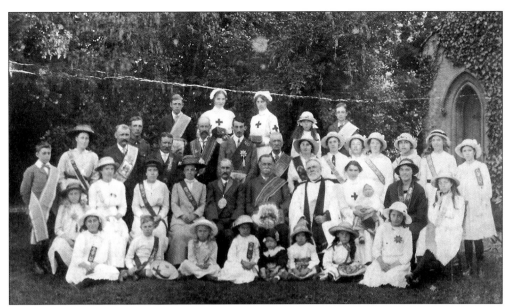

Hospital Sunday, 1913. Members of the Christchurch and Poole branches of the Independent Order of Oddfellows gathered outside the church. Hospital Sundays were fund-raising events for the local voluntary hospitals. With them is the Revd Joseph Johnson, Vicar of Burton from 1913-21. The first vicar was Revd T.H. Bush, who came as the curate in 1862 before the church was built and lived at Staple Cross Lodge, which he turned into a school. It is now the Manor Arms public house. Revd Bush left to become the vicar at the Priory Church.

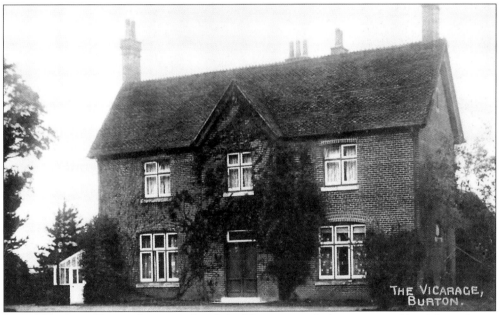

Burton Vicarage, Preston Lane, is a lovely building, currently in use as a residential care home called the Avon Lee Lodge. Another Joseph Lander building of around 1885, its grounds extended to the Salisbury Road. Rumour has it that the incumbent's wife disapproved of the original orientation intended for the building; her reluctance to look out over humble cottages resulted in the vicarage facing the countryside rather than the village.

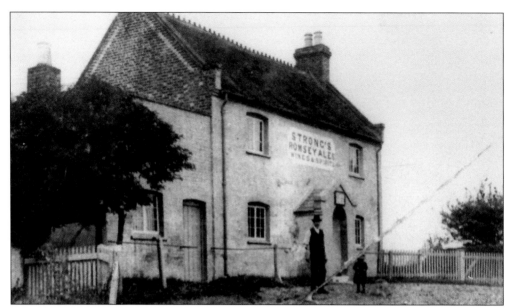

The old Oak Inn, *c.* 1914, with landlord Harry Blandford and his grandson William Jones. Henry Blandford was the landlord for about fifty years, during which time this small country pub served home-grown produce to their visitors, including home-cured ham and bacon and home-made butter. The unpretentious little inn was rebuilt in about 1932 in a grand mock-Tudor style.

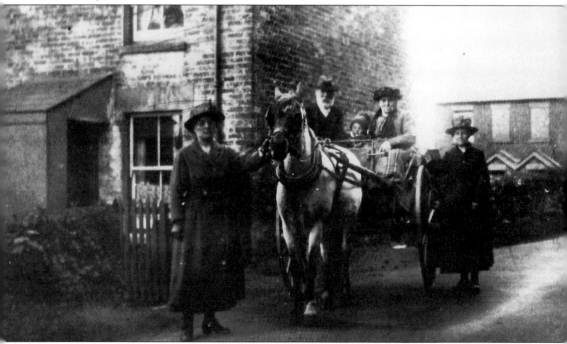

Holly Cottage in the foreground and pair of unnamed cottages behind, edge on to Stony Lane. Figures in the road are identified as members of the Ferris family and the picture appears to be Edwardian. In place of the cottages today are a group of bungalows opposite the junction with Martins Hill Lane.

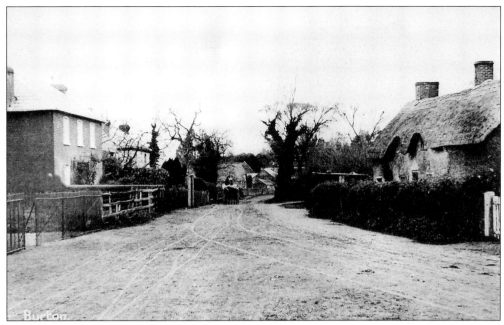

Two views of Salisbury Road cottages looking north, near Preston Lane. Mr Whitfield's thatched cottage, right, has been replaced by a brick terrace, and the house just in view opposite is now Woodstock Road. Below, seen here around 1920, the village hall beyond the cottage was opened in 1913 and cost £220. On the cart is Charlie White (see page 44) with his horse Smart; standing on the right is his daughter, Mabel, and Elsie Short. The other two girls are the Parker sisters. The group takes for granted the freedom to stand in the roadway as a matter of course, which today's conditions make most inadvisable.

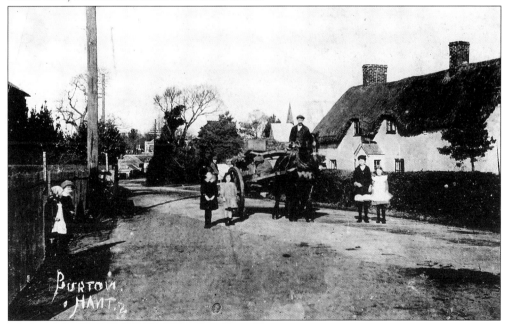

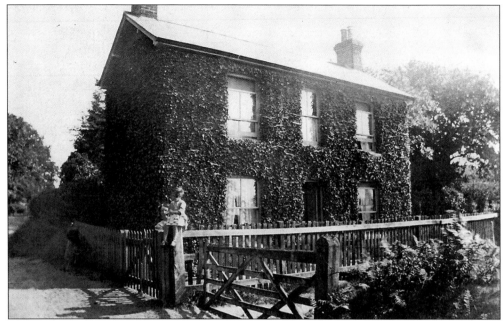

Clyde Cottage, Martin's Hill Lane, early twentieth century. This Victorian cottage is essentially the same today apart from the ivy, but the lane outside has lost its rural character. In 1911 a sale of the contents included an American striking clock, an antique walnut tea caddy with glass liner and a mahogany dining table, suggesting the occupants were of some means.

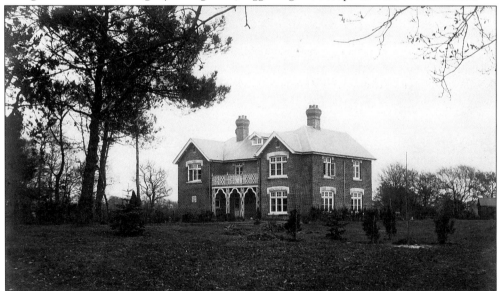

Burton Close, 1904. Probably new at the time and situated behind Clyde Cottage, it survives in an altered form today. The home of Captain Orford Somerville Cameron RN, a 'nice, kindly old man' (Herbert Druitt), who earned a silver medal from the Royal Humane Society for the rescue of a drowning sailor in 1861. He died here in 1921. Brother of the distinguished Gen Sir William Gordon Cameron of Nea House, Highcliffe, and a veteran of campaigns in the Baltic and China, for which he received further awards, Captain Cameron was also a collector of ceramics and shells, and an accomplished artist.

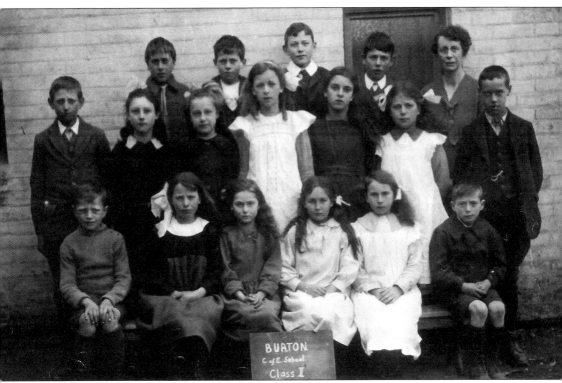

Burton School, 1920. Back row: Bert Parker, Terence Wingent, Charlie Vivian, Arthur Summers. Middle row: Walter Jones, Connie Tizard, Gladys Newham, Mabel White, -?-, Dora Bassett, Leslie Luckham. Front: Percy White, Gertie Trivett, Dorothy Parker, Clare Ingram, Flossie Etheridge and ? Summers. The teacher is Miss Gulliver, who succeeded the awe-inspiring Miss Mona Robinson. After their primary education was completed the children had to walk to the senior school in Christchurch. The village school is still used for the infants, but the juniors were provided with a new school in 1963.

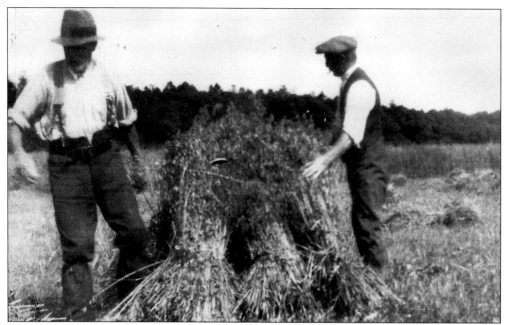

Stooking at Waters Farm, 1920, showing Harry Blandford with a Mr Hunt. Mr Blandford is previously mentioned as the landlord of the Oak Inn. Mr Hunt was probably Mr William Hunt, the farmer at Waters Farm. The harvesting and gathering up of the crop was done by hand and the neat rows of stooks were then collected by a farm cart. Burton, of course, covers a large agricultural area, the families involved being mainly the Crabbs, Farwells, Landers, Hunts and Boltons.

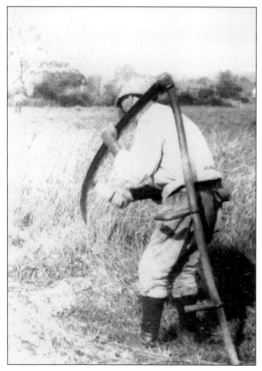

Emanuel Wellstead cutting corn and sharpening a scythe in the vicinity of the Lamb Inn, c. 1900 - another manual operation entirely mechanised in the last half a century or so.

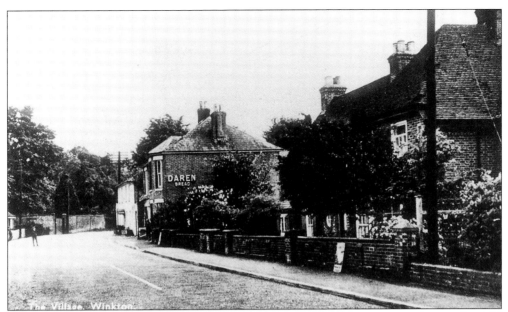

Winkton village, date unknown. Traffic today rushes past a most interesting house, Gosfield Cottage, on the right. Purported to be in the region of 400 years old, the presence of a water pump in the garden inscribed '1765' and a working well indicate a building of great age. It was for many years until about 1955 owned by the Misses Dacombe who built a chapel alongside as a religious retreat and occasionally opened the gardens to the public for charity. A 'Daren bread' sign hangs on Winkton Place, baked daily by Walter Stainer and 'recommended by doctors throughout the country' (1933 advert).

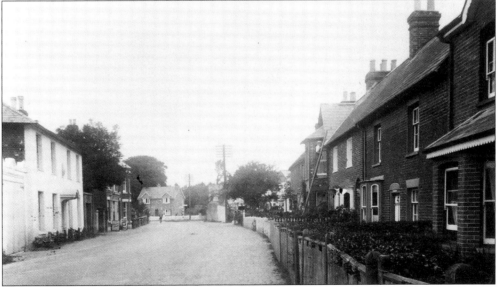

View in the other direction. Monk's Revel is on the left, with its curious unicorn figure in the niche above the door, once home to the Joliffe ladies. In two of the cottages opposite lived the Rowe sisters: Robina, who taught with the missionaries in India, and Dorothy, who founded the Bournemouth Little Theatre Club in 1919. The Club opened at the Palace Court Theatre in 1931, making it the only such club in the country to have its own theatre.

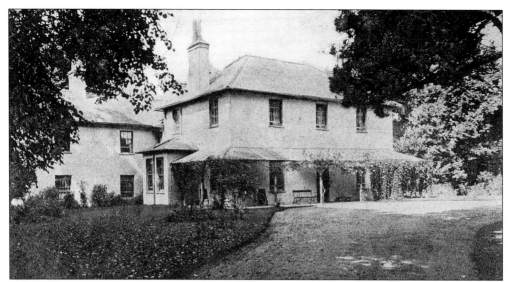

Winkton House, c. 1905, which today seems quite a recent construction because of the verandah being removed and the windows replaced. One James Jopp demolished the original manor house here in the early nineteenth century (the ornamental doorway was probably used for the Masonic Hall, Christchurch) and gave his name to Jopps Corner at the junction with Stony Lane. He was Overseer of the Poor for the tything of Winkton in 1821 and raised funds to provide seats for 100 poor people in the Priory Church. Grantley Berkeley (see page 107) lived here before Beacon Lodge. The house passed into the Mills family of Bisterne in 1860.

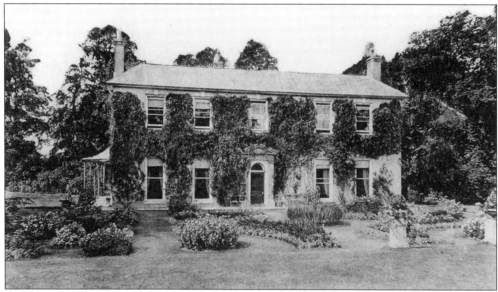

Winkton Lodge, c. 1900, the present Homefield School, seen from the back. It was the home of the Christchurch MP and naval expert, Admiral Walcott, who died in 1868. On the chimney the date 1706 is inscribed. From 1890 until their deaths by 1920, the house belonged to sisters Jane and Caroline Lassells, who memorably appeared before the magistrates in 1905 charged with failing to pay the Poor Rate. They said they did not object to paying, only to being compelled to. Caroline was a watercolour artist. As well as the formal flower beds seen here, the 24-acre grounds included a walled garden, a farm and an octagonal dairy house.

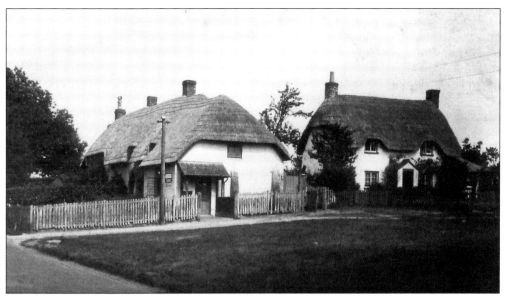

Hinton Post Office and general store, *c.* 1920, run by Mr C. Penton, postmaster. Replacing a mail cart service from Christchurch in about 1888, this pretty thatched shop, left, was another casualty of fire in 1928. Traces of its cob walls may still be seen on the verge. To its left, out of the picture, the village also once had a bakery. The cottage on the right is called Greenhill. The fast road outside, where the speed limit was then 20 mph, has been widened to include all of what was the front garden of the shop.

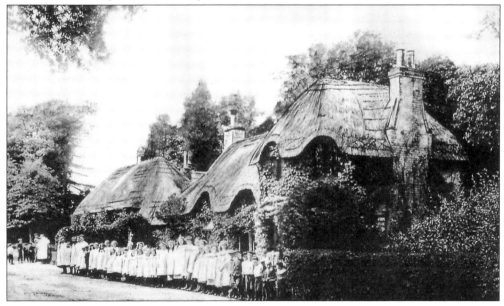

Hinton School, undated. Founded in 1846 by Sir George and Lady Meyrick for their estate workers' children, the only thatched school in the county (Hampshire) was closed after a bitter fight in 1967, as only twenty-three children remained. It is cob encased in brick and can still be seen, but the quaint eyebrow-roofed thatched building adjacent, the schoolmaster's home, was unaccountably allowed to tumble down. Since the first edition of this book, the building on the right burnt down, so no trace remains of either beautiful cottage.

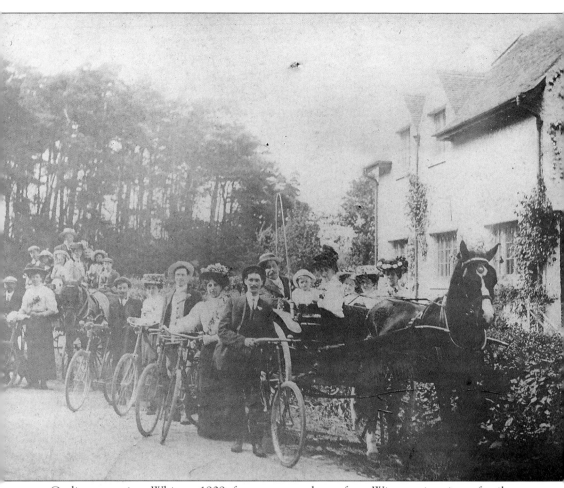

Cycling excursion, Whitsun 1909, from a postcard sent from Winton picturing a family group outside Applegarth just around the corner from the Cat and Fiddle, in Ringwood Road. The cottage is still there, though most modern car-cocooned passers-by would miss it. If the cyclists had come all the way from Winton, it is a small miracle how the ladies managed to hang on to their substantial hats and pedal in that attire over such a distance. Cycling was an immensely popular pastime, there being clubs in both Christchurch and Mudeford before the roads were monopolised by motor traffic.

St Michael's church in the 1920s, and interior, *c*. 1905. The inside has been decorated for some occasion, possibly a harvest festival. The church was erected as a chapel of ease in 1772 by Joseph Jarvis Clarke to serve the tiny community: the population in 1881 was 284. The story goes that a flood between Roeshot Hill and Christchurch caused the death of several people travelling to a Mass in the Priory in the fifteenth century, after which a petition for their own church was met by the erection of an earlier church known as St Anne's. Where this was and whether the myth is fact is unknown. The interior is unaltered apart from the arched screen, here cleverly adorned with flowers.

No compilation of Hinton photographs is complete without the inclusion of the charming Cat and Fiddle, one of the most ancient roadside inns in the country. Like so many hostelries and the like, it had a reputation as a smugglers' haunt, as did the Ship in Distress, the Hoy, the Eight Bells, the Lamb Inn and many others. It was a coaching inn - the stage coaches to Holmsley station would change horses here. The once familiar inn sign shows the cat about to play the tune *Take this Cup of Sparkling Wine*, and over the original doorway can be seen an intriguing wood relief illustrating the nursery rhyme story of the pub's name (possibly a corruption of *Catherina Fidelis*). One reference puts the carving's age as 300 years and notes it was severely damaged during the last war. Apart from this mention, its origins remain mysterious.